GUMOIL PHOTOGRAPHIC PRINTING

REVISED EDITION

Karl P. Koenig

**Focal
Press**

Boston Oxford Auckland Johannesburg Melbourne New Delhi

Focal Press is an imprint of Butterworth–Heinemann.

Copyright © 1999 by Karl P. Koenig

⟨R A member of the Reed Elsevier group

Butterworth–Heinemann supports the efforts of American
Forests and the Global ReLeaf program in its campaign for
the betterment of trees, forests, and our environment.

Library of Congress Cataloging-in-Publication Data
Koenig, Karl P.
 Gumoil photographic printing / Karl P. Koenig—Rev. ed.
 p. cm.
 Includes bibliographical references.
 ISBN 0-240-80367-1 (alk. paper)
 1. Photography—Printing processes—Oil. I. Title.
TR443.K64 1999
773' .8—dc21 99-27003
 CIP

British Library Cataloguing-in-Publication Data
A catalogue record for this book is available from the British Library.

The publisher offers special discounts on bulk orders of this book.
For information, please contact:
Manager of Special Sales
Butterworth–Heinemann
225 Wildwood Avenue
Woburn, MA 01801-2041
Tel: 781-904-2500
Fax: 781-904-2620

For information on all Focal Press publications available, contact our
World Wide Web home page at: http://www.focalpress.com

10 9 8 7 6 5 4 3 2 1

Printed in the United States of America

GUMOIL
PHOTOGRAPHIC
PRINTING

*This book is dedicated to the memory of my parents,
Professor Karl F. Koenig and Ruth Vanderpoel Koenig.*

Contents

10

Advances in the Gumoil Process **115**

Appendix **129**

Annotated Bibliography **131**

Annotated Suppliers List **139**

Glossary **143**

List of Figures

About the Author

Karl Koenig's formal education includes a B.A. from Trinity College in Connecticut, and M.S. and Ph.D. degrees in clinical psychology from the University of Washington. This was followed by professorships at Stanford University and at the University of New Mexico in the psychology and psychiatry departments. In 1981, he left teaching and research to enter private practice in Albuquerque.

Photography, painting, and drawing are among his lifelong interests. He learned about alternative photographic printing methods in 1989 and 1990, which led him to the discovery of gumoil. For the first time, the technique is described in depth in this book.

The author continues to write and teach about gumoil, make gumoil prints, and show his work. He continues to experiment with gumoil and other methods outside of mainstream photography.

Acknowledgments

My wife, Frances Salman Koenig, has been a vital source of support for my work in gumoil and of my writing. Our children—Lynn, Lisa, Nathan, and Julia—have been remarkably tolerant of my preoccupation with photography over the years and the considerable time it has taken to work out new methods of printmaking. As adults they enjoy my work and hang it on their walls in Albuquerque, Washington, Hood River, and Manhattan, respectively.

Books like this depend heavily on the encouragement and stimulation of experts. I particularly want to acknowledge the effect on me of the body of great work known as Pictorialism, a movement in photography corresponding roughly in chronology and purpose to Impressionism in painting. From an artistic and technical standpoint, I owe a significant debt to Betty Hahn, professor emeritus of fine art at the University of New Mexico. I am grateful to those who have bought the work or allowed it to hang in their galleries but, most especially, I am grateful to those whose spirit of adventure has led them to make gumoil prints themselves.

I hope the revised edition with the chapter on computer assistance will encourage others to take the plunge.

Introduction to the Revised Edition

The purpose of this revision is to include new developments in the process, especially the contribution of digital technology to the greater ease and improvement of gumoil print-making. All of the new color plates (Plates 6 through 10) were contact printed initially from interpositives printed on computer paper. The original film images were scanned into a computer.

The Gumoil Method and Its Origins

AN OVERVIEW

The term *gumoil* was recently coined to describe an innovative method of making polychromatic photographic prints (Koenig 1991) that was derived from an earlier, but rather grainy, method described by Wade (1978) to produce monochromatic images. The new gumoil process consists of several components, some of which are shared by earlier and historically important photographic printing processes, but gumoil should not be confused with them despite some similarity among the numerous names.

Even experts such as art historians, photographic artists, and photographic technologists become confused by the profusion of terms, the similarity among various terms, and the overlapping of certain technical aspects. This may seem surprising for an endeavor that ultimately involves chemistry and optics. What confounds any attempt to make photographic methods into a pure and reliable technology is that photography has been

coated methods being applied to pictures produced for purely journalistic, commercial, scientific, or personal purposes. In all these cases, there are good reasons for using conventional printing methods, but these are not the reasons why one would use premodern methods. Consequently, hand-coated methods are more or less restricted to the purpose of creating a fine art photograph. On occasion, such photographs are useful in advertising because they have the power to evoke a specific mood.

The hand-coated methods should not be considered interchangeable even though they are grouped together here for the purpose of discussion. An image that is exquisite in platinum, for example, may be ridiculous rendered in gum bichromate, cyanotype, or Vandyke. Each of the fifteen or twenty methods is unique, and each produces highly characteristic results. Some are more versatile than others. Vandyke and cyanotype yield an uncomplicated surface and a limited color and tonal range as compared with, say, gumoil or gum bichromate prints.

Gumoil is only marginally similar to some other now slightly obsolete fine art photographic processes such as oil and bromoil, which employ oil-based inks. The similarity, when it exists, involves the look that comes from using hand-coated papers, from carefully manipulated surfaces, from the textures, and from the painterly impact of the final images. Indeed, gumoil can be applied in such a way as to achieve the look and feel of the old methods even though it is a new process (Koenig 1991).

Although the component steps of gumoil printing are explained in later chapters, it is important to keep in mind that gumoil is new, still in the experimental stage, and no one part of the method has become fixed or absolute. If you decide to print in gumoil, you will almost certainly advance some aspect of the method, even if only by accident, because so many variables are involved that none has yet been exhaustively investigated. You can share in the excitement of using a process few others have even heard about and only a tiny number have actually attempted. The prints it can generate can be startling, beautiful,

coated methods being applied to pictures produced for purely journalistic, commercial, scientific, or personal purposes. In all these cases, there are good reasons for using conventional printing methods, but these are not the reasons why one would use premodern methods. Consequently, hand-coated methods are more or less restricted to the purpose of creating a fine art photograph. On occasion, such photographs are useful in advertising because they have the power to evoke a specific mood.

The hand-coated methods should not be considered interchangeable even though they are grouped together here for the purpose of discussion. An image that is exquisite in platinum, for example, may be ridiculous rendered in gum bichromate, cyanotype, or Vandyke. Each of the fifteen or twenty methods is unique, and each produces highly characteristic results. Some are more versatile than others. Vandyke and cyanotype yield an uncomplicated surface and a limited color and tonal range as compared with, say, gumoil or gum bichromate prints.

Gumoil is only marginally similar to some other now slightly obsolete fine art photographic processes such as oil and bromoil, which employ oil-based inks. The similarity, when it exists, involves the look that comes from using hand-coated papers, from carefully manipulated surfaces, from the textures, and from the painterly impact of the final images. Indeed, gumoil can be applied in such a way as to achieve the look and feel of the old methods even though it is a new process (Koenig 1991).

Although the component steps of gumoil printing are explained in later chapters, it is important to keep in mind that gumoil is new, still in the experimental stage, and no one part of the method has become fixed or absolute. If you decide to print in gumoil, you will almost certainly advance some aspect of the method, even if only by accident, because so many variables are involved that none has yet been exhaustively investigated. You can share in the excitement of using a process few others have even heard about and only a tiny number have actually attempted. The prints it can generate can be startling, beautiful,

papers with inferior ones. This carping is something of an inside joke to those photographers who mix their own chemicals and painstakingly coat each piece of paper they need.

Contemporary photographic technology permits a printer to make dozens of finished prints in an afternoon work session. Gumoil, and some of the other hand-coated methods, require several weeks to produce a single finished print. The heavy consumption of time is somewhat mitigated by the fact that many pieces of work can be in process simultaneously. The period of development required by a given piece, which necessarily stretches over a period of weeks, also allows printers to intervene at several points and provides them with enough time to consider and then reconsider the colors, the manipulations by brush, the etchings, the masking, and so forth, all of which can be combined to pull out the best possible final image. It is not that this always works, but the extra time allowance (or requirement, if you prefer) of gumoil and the other hand-coated methods is a substantial and unappreciated advantage over the way most modern photography is practiced.

In recent years, there has been a small but persistent renaissance in these premodern methods of photographic printing. Such printing methods are sometimes called *alternative* or *nonsilver*, but such terms are not particularly helpful because they are inaccurate. Virtually every method referred to in this book, except electronic ones, depends on silver nitrate. The silver is generally in the film, however, not in the paper, as it is in modern papers. The exceptions to this rule are hand-applied methods that use silver nitrate crystals—for example, Vandyke, kallitype, collodion, albumen, daguerreotype, tintype, and salted paper. In any event, who is to say what constitutes an "alternative" method? Methods experience popularity during one era and disuse in another.

You will need to ask yourself whether your particular images and the purpose(s) to which you want to put them are suitable for one or another of the laborious hand-coated methods. For example, it is not easy to imagine any of the hand-

practiced by millions of people with various backgrounds, from dozens of cultures and nations, with an infinity of purposes, over a period of approximately 150 years. Photography is quite a lot like food preparation, which ranges in quality, style, and nutritional value from Michelin-rosetted haute cuisine to utilitarian McDonald's-type fast food to the crudest life-sustaining matter.

The premodern methods of photographic printmaking with which gumoil may occasionally be compared or confused include gum bichromate (or gum dichromate) printing as well as the oil or bromoil printing methods. Table 1.1 summarizes the names, practical references, types of internegative or interpositive required, and methods. Like gumoil, each of these early printing methods is labor-intensive, involving a large amount of handwork and requiring considerable practice in order to make reliably acceptable pictures. It is the handwork and the lengthy time span involved that allow the printer to achieve significant artistic control over the final image. Gumoil has much of the painterly look and texture of the older processes from which it recently descended (Koenig 1991).

As with the other premodern, hand-coated methods, gumoil differs substantially from the current universally understood and expected method of photographic printing. Contemporary printing, whether at the one-hour drop-off stand or at the custom laboratory, is invariably carried out on commercial papers prepared at the factory with a highly sensitive coating of gelatin (or resin) in which silver nitrate crystals are suspended.

Modern printing is almost miraculously fast, convenient, cheap, and replicable. Manufactured papers have been available for decades in an enormous variety of grades and surfaces, saving the printer the considerable trouble of mixing and applying coatings by hand to individual sheets. No matter how exquisite and reasonably priced the papers, there is never an end to the complaints from professional photographers about how venal corporations have now replaced the wonderful old printing

The Gumoil Method and Its Origins

AN OVERVIEW

The term *gumoil* was recently coined to describe an innovative method of making polychromatic photographic prints (Koenig 1991) that was derived from an earlier, but rather grainy, method described by Wade (1978) to produce monochromatic images. The new gumoil process consists of several components, some of which are shared by earlier and historically important photographic printing processes, but gumoil should not be confused with them despite some similarity among the numerous names.

Even experts such as art historians, photographic artists, and photographic technologists become confused by the profusion of terms, the similarity among various terms, and the overlapping of certain technical aspects. This may seem surprising for an endeavor that ultimately involves chemistry and optics. What confounds any attempt to make photographic methods into a pure and reliable technology is that photography has been

and quite often, both. The pictures usually remain recognizable as photographic in origin but transformed, sometimes radically, by the interaction of the original image with gum arabic, oil paints, bleach, and the underlying texture and color of the thick watercolor paper support on which they must be printed. Although pictures may be printed in multiple colors and even be worked to simulate "natural" colors, it is not a true color photographic process; the choice of colors and their sequencing is entirely up to the printmaker.

The gumoil method resulted from the convergence of several elements used by fine art photographic printers at the turn of the century and before. The images laid down on heavy watercolor paper by the method and its variants are often reminiscent of the work associated with early revolutionary photographic printmakers such as Demachy, Käsebier, Steichen, Emerson, and several others associated with major photographic styles and movements between 1880 and 1915. In some respects, photographic printing using the gumoil process feels like printing using the old methods, but it can also be employed in strikingly bold and modern ways. Therefore, this book is not simply for aficionados of the quaint but tedious methods of early photography.

The gumoil method can be mastered by people with a measure of photographic and artistic ability who want to explore some very different ways of creating images of considerable beauty. Aspiring gumoilists need not have great technical proficiency or modern equipment. They need not own a cumbersome view camera or possess a sophisticated understanding of chemistry, beyond a willingness to follow some simple recipes. No densitometer readings or zone system are needed to produce usable negatives or enlarged positive transparencies. Indeed, even though the old methods (and this new one) are always labor-intensive and time-consuming, they also don't require much in the way of high technology.

There are some basic equipment requirements for gumoil, described more thoroughly in later chapters. A camera that takes

good-quality black-and-white negatives is essential, and although the negatives can be commercially developed, there isn't much point in doing so since making the subsequent large positives will require the gumoilist to perform home darkroom work. A 35-millimeter camera with fine-grain film and a good lens provides a negative of sufficient size for enlargements up to about 125 square inches, perhaps more. The darkroom must include an adequate enlarger and standard darkroom equipment. A contact printing device and a source of strong ultraviolet radiation (the sun or a sun lamp) are essential for making the latent gum prints on watercolor paper.

Gumoil requires effort, planning, and luck, in about equal proportions. After the equipment and supplies are in hand, an appropriate original negative must be selected. This will have adequate, not overpowering, contrast and a good tonal range. Extremely thin or dense negatives do not lead to good results in gumoil, although they may be useful for other processes. The negative is enlarged onto another piece of film that is a bit larger than the size of the desired final print (to allow for margins). This enlargement produces a positive transparency and is used for contact printing the sensitized and gummed paper under the sun or lamp. At this stage, there is no added pigment in the gum coating, but the chromate will produce a faint and quite unattractive olive-yellow picture (in negative) on the paper. When it is tray-developed in running water, areas corresponding to the dark part of the image will open up in the gum on the surface. It is to these open areas that the oil paint will be attracted, while the areas that remain gummed will resist oil paint. Polychromatic prints are made by subsequent etching of remaining thin edges and areas of gum followed by further oil coloring. As the underlying paper is gradually exposed by etching, further applications of color may be made.

In the other hand-coated photographic print processes, etching does not occur. In gum bichromate, for example, if a

polychromatic effect is sought, subsequent layers of different-colored gum must be built up. Each layer must be reexposed to light under the large negative (not positive) with the negative in precise registration with the image below it if blurring or ghost images are to be avoided. Obtaining exact registration with a piece of paper that may shrink significantly each time it is gummed and water-developed can be frustrating. Gumoil does not require registration because only the single exposure on sensitized gum is ever made. All pigmentation is added and all etching takes place in a well-lighted room, and registration and shrinkage play no part in the equation. This is a major advantage that gumoil enjoys over other polychromatic methods using hand-coated paper.

A gumoil print can be built in this fashion starting with any suitable black-and-white negative. Because the prints are made from tubed oil paints rubbed into high-quality paper, they can be very rich in color and texture, infinitely varied in hue and intensity, of virtually any final print size, and archival in the extreme. The prints may be subtle and delicate with just one or more closely related oil colors to produce a very pure photographic effect. Such an image can be made to yield a monochrome, duochrome, or gentle polychrome. The pictures can be rendered in fairly natural or realistic colors, depending on the combination of pigments chosen, or they may be printed surreally with fantastic color compositions.

Although the gumoil print starts out as a rather straightforward black-and-white photograph, it may end up looking only remotely like a photograph. This is due in part to the range of colors and tones possible and in part to the method's susceptibility to a variety of manipulations. These include masking and other precision coloring methods, brushing, dabbing, and spraying to lighten or darken selectively. Gumoil may be combination printed (in registration) with a host of other coatings such as silver, platinum, palladium, gum bichromate, Vandyke, and cyanotype.

THE GUMOIL METHOD:
ITS PLACE IN THE REPERTOIRE
OF HAND-COATED METHODS

The passage of a century and a half has produced dozens of printing methods and variations along with a veritable jungle of terminology. There is no single guide to bring you safely through it. Of considerable value, however, are the following: *Focal Encyclopedia of Photography* (1965, 1993), Henney and Dudley (1939), and Witkin and London (1979). Furthermore, there is probably no single location where good examples of every process can be viewed, either as original prints or in reproduction. Considerable, but insufficient, help has been offered by authors who have provided glossaries, histories, and surveys of various processes (Crawford 1979; Hirsch 1991; Wade 1978).

What is needed eventually is a compendium of terms, definitions, full discussions of formulas and procedures, and finally, superbly reproduced exemplars of each and every process. The reproductions must be in color because so many of the early processes, even when nominally black-and-white, varied subtly in hue due to the vagaries of pigments, colloids, or paper support. Photomacrographs (30× enlargements) should likewise accompany each process so that one can clearly see the visible materials and how they rest on or within the paper fibers. One book that approaches this level of thoroughness is published by Kodak (Reilly 1986), but even this effort falls seriously short because it does not include palladium, Vandyke, oil, bromoil, carbro, or gum bichromate prints (although a related form of the latter, carbon printing, is included).

An additional challenge to compiling such an encyclopedia is that many of the old masters of photography combined more than one technique on the same print. For example, both Käsebier and Steichen were fond of overprinting their platinotypes with one or more layers of tinted gum bichromate, which they reexposed and redeveloped in careful registration with the un-

derlying print. There are many premodern prints at whose composition we can only guess.[1] To further complicate the analysis, such prints were frequently manipulated by scratching, penciling, rubbing, and brushing (while still soft and wet). Many early photographic artists were less concerned with precise rendering than with creating relatively ambiguous images that would require the viewer to form an interpretation.

Table 1.1 contains brief summaries of several control processes drawn, in part, from the work of Henney and Dudley (1939) and from the *Focal Encyclopedia of Photography* (1965, 1993), and to which gumoil has now been added. The table also includes author references so that you can readily find practical and detailed accounts of how to use a particular process. "Control processes" are those that are intrinsically easy to manipulate during some stage of print development. It is these premodern methods that were used by many master printers but are relatively rarely seen, even in museums, and with which you may want to experiment. Silver nitrate–based processes (as well as ferricyanide-, platinum-, and paladium-based processes) are not included, although many of the control processes can be used to overprint them in registration. It might be parenthetically mentioned that the latter processes can produce prints that may also be directly and individually manipulated by toning, solarizing, and hand coloring.

The newly worked out process of gumoil is conceptually but inversely related to the better-known and historically significant method of gum bichromate (or dichromate) printing. Gum has alternately been rejected and embraced as a fine art photographic printing method precisely because it can be grossly manipulated. Some purists felt that no serious (i.e., artistic) printers should use it because alterations of the "true" image during printing were so easy to manage that the process had been debased. Gum can also be used to produce "straight" images that are nearly indistinguishable from certain carbon, albumen, and oil prints. Scopick (1991) reprints a picture made in

Table 1.1 *(Continued)*

Process	Printer Transparency	Comments/Description
Gum bichromate (also known as aquatint, direct carbon, pigment prints, or arabin) Crawford (1979), Hirsch (1991), Scopick (1991)	Enlarged negative, only by contact	Ammonium or potassium bichromate mixed with gum, pigmented with water-soluble colors. Monochrome, polychrome, and three-color separations.
Gumoil	Enlarged positive, only by contact	Unpigmented, sensitized gum is contact printed under a positive. Latent print is developed. Oil color is rubbed in directly. Bleaching then etches away additional gum, and further oil layers may be laid down. Print is easily manipulated or spoiled.
Oil Nadeau (1985)	Enlarged negative, only by contact	Difficult to find and/or make papers. It follows a printing process similar to bromoil. See Nadeau (1985) for making oil papers by hand. Hand inking is the chief advantage and the chief difficulty.
Platinum-gum Crawford (1979) for both processes	Enlarged negative, only by contact	Richness of a platinum print is augmented with overprinting(s) of colored, sensitized gum coatings. This can be done over silver and palladium prints as well.

Table 1.1 *(Continued)*

Process	Printer Transparency	Comments/Description
Gum bichromate (also known as aquatint, direct carbon, pigment prints, or arabin) Crawford (1979), Hirsch (1991), Scopick (1991)	Enlarged negative, only by contact	Ammonium or potassium bichromate mixed with gum, pigmented with water-soluble colors. Monochrome, polychrome, and three-color separations.
Gumoil	Enlarged positive, only by contact	Unpigmented, sensitized gum is contact printed under a positive. Latent print is developed. Oil color is rubbed in directly. Bleaching then etches away additional gum, and further oil layers may be laid down. Print is easily manipulated or spoiled.
Oil Nadeau (1985)	Enlarged negative, only by contact	Difficult to find and/or make papers. It follows a printing process similar to bromoil. See Nadeau (1985) for making oil papers by hand. Hand inking is the chief advantage and the chief difficulty.
Platinum-gum Crawford (1979) for both processes	Enlarged negative, only by contact	Richness of a platinum print is augmented with overprinting(s) of colored, sensitized gum coatings. This can be done over silver and palladium prints as well.

Table 1.1 *(Continued)*

Process	Printer Transparency	Comments/Description
Dusting on Wade (1978)	Positive transparency, only by contact	An impractical procedure that employs honey or sugar mixed into bichromated gum. Exposure of coated paper results in to-be-dark areas remaining sticky, light areas not. Powdered pigment blown onto surface sticks to sticky areas. A fixative coating is applied.
Flexichrome Unavailable	Enlarged negative, only by contact	Early commercial process produced full (but not true) color prints, especially for magazine reproduction. Ingredients included unique replacement dyes.
Fresson (or Artigue) Nadeau (1987)	Enlarged negative, only by contact	In bygone days, the paper was commercially available, tightly controlled by two Fresson laboratories. Similar to gum bichromate except glue and/or gelatin is used, and instead of water development, a soup of sawdust and warm water is poured over the image, yielding a matte surface. Despite the current surrounding mythology, Henney and Dudley (1939) described it as "requiring little technical skill."

(continued)

Table 1.1 Hand-Coated Control Processes

Process	Printer Transparency	Comments/Description
Bromoil Crawford (1979), Nadeau (1985)	Negative under enlarger or by contact	Sensitized gelatin brushed on top of a bleached bromide print from which a final print is made by inking with brush or brayer after soaking. Swollen gelatin repels greasy ink, hard gelatin areas attract.
Bromoil transfer Nadeau (1985)	Negative under enlarger or by contact	Multiple prints possible using gelatin bromide print (as above) as a printing "plate." Much manipulation possible, as in bromoil.
Carbon transfer Nadeau (1986), Crawford (1979)	Enlarged negative, only by contact	A special gelatin-blackened (or otherwise colored) tissue is sensitized and exposed. Then it is transferred to a plastic or paper support.
Carbro Crawford (1979), Nadeau (1986)	Enlarged negative, only by contact	Insolubility of gelatin coat is achieved by a chemical interaction between silver image of a bromide print squeeged into contact with sensitized carbon (black or colored) tissue.
Carbon, three color Crawford (1979)	Three enlarged negatives, only by contact	A complex process involving color separation negatives printed on separately colored sensitized tissues in cyan, magenta, and yellow. After exposure, these are placed one atop the other to produce one full, accurate color print on a support (usually a plastic surface).

derlying print. There are many premodern prints at whose composition we can only guess.[1] To further complicate the analysis, such prints were frequently manipulated by scratching, penciling, rubbing, and brushing (while still soft and wet). Many early photographic artists were less concerned with precise rendering than with creating relatively ambiguous images that would require the viewer to form an interpretation.

Table 1.1 contains brief summaries of several control processes drawn, in part, from the work of Henney and Dudley (1939) and from the *Focal Encyclopedia of Photography* (1965, 1993), and to which gumoil has now been added. The table also includes author references so that you can readily find practical and detailed accounts of how to use a particular process. "Control processes" are those that are intrinsically easy to manipulate during some stage of print development. It is these premodern methods that were used by many master printers but are relatively rarely seen, even in museums, and with which you may want to experiment. Silver nitrate–based processes (as well as ferricyanide-, platinum-, and paladium-based processes) are not included, although many of the control processes can be used to overprint them in registration. It might be parenthetically mentioned that the latter processes can produce prints that may also be directly and individually manipulated by toning, solarizing, and hand coloring.

The newly worked out process of gumoil is conceptually but inversely related to the better-known and historically significant method of gum bichromate (or dichromate) printing. Gum has alternately been rejected and embraced as a fine art photographic printing method precisely because it can be grossly manipulated. Some purists felt that no serious (i.e., artistic) printers should use it because alterations of the "true" image during printing were so easy to manage that the process had been debased. Gum can also be used to produce "straight" images that are nearly indistinguishable from certain carbon, albumen, and oil prints. Scopick (1991) reprints a picture made in

gum through color separation negatives that is extraordinarily true to life in its colors.

The joy of gum bichromate printing has in recent times been enthusiastically rediscovered by fine art photographers. It plainly deserves its reputation as a fascinating and versatile method and is often presented in contemporary photography courses as belonging to the "alternative" photographic techniques. The gum bichromate method is competently explained in several modern books, including Crawford (1979), Hirsch (1991), Newman (1977), and Scopick (1991). Luis Nadeau has written definitive and extremely useful works on gum, oil, and bromoil printing. His work (1985, 1987) should be consulted by any serious student of the early processes.

Gum bichromate printing depends on a thick colloid (particles of powdered gum arabic suspended in water) mixed together with a light-sensitive material (usually, a solution of potassium bichromate) and further mixed together with a water-soluble pigment. The most commonly used pigments are tubed watercolors such as those made by Windsor and Newton or Grumbacher. The chromate has the photochemical property of making the gum hard where light strikes it but allowing it to stay soft and very soluble where the light doesn't touch it. Thus, the hard colored gum stays on the paper, and the soft colored gum rinses off with gentle washing. Scopick's book helps one understand how this can best be done to build up an intensity in a single color or how, with color separation black-and-white negatives in registration with each other, it can produce true three-color prints.

The gumoil technique is best understood as the conceptual and procedural mirror image of gum bichromate printing. The gumoil process requires that *no* pigment be added to the sensitized gum arabic. The gum will harden where light touches it, but in this case, the light touches it through a black-and-white *positive* transparency. The gum will dissolve away from places where the light has not penetrated the positive, and this will leave open spaces on the paper. Into these spaces, *oil paints*

rather than water-soluble colors can be rubbed when the gum and paper have dried. The residual gum serves as a resist to the oil-based pigments, and the open areas in the paper attract and absorb the oil paints. No etching is performed in regular gum bichromate work, whereas it is a central modality in gumoil.

It was in the process of making prints with hand-coated methods requiring enlarged negatives that this writer began to despair of the apparent waste inherent in those processes; that is, the necessity of making enlarged positives whose only use was for contact printing onto a second piece of film to make enlarged negatives. Using the large positives directly began as an experiment to see whether oil paint–based positive prints could be produced. The idea of etching away some of the residual gum with bleach came along within a few days, and the potential for polychromatic printing was quickly realized.

The use of materials and procedures associated with the premodern processes results in prints that have a distinctly different visual impact and, when successful, a different emotional impact as well when compared with the modern, commercially prepared papers, which depend on silver salts (for sensitizing and pigmentation). Gumoil and premodern prints cannot be made without a transparency of the same size as the final image, and they therefore depend on some form of direct contact printing under a light source far more powerful than an enlarger can supply.

Among the early and exotic methods for printing fine photographic art are oil pigment, bromoil, carbon, and carbro. Each depends on a sensitized colloid, gelatin, and is printed with a negative. Either moisture-engorged gelatin acts as a resist to the application of pigment-bearing oil, or the gelatin carries a water-soluble pigment in a process very much like gum bichromate printing.

Prints made from the premodern methods, to which gumoil has a definite affinity, often have a soft, handmade look to them. Depending on the use of brushing and wiping, the prints may look quite painterly. As the manipulations are carried for-

ward, the prints become virtual monotypes, impossible to reproduce except in the most approximate fashion.

THE GUMOIL METHOD: A HISTORICAL PERSPECTIVE

Gumoil can legitimately trace its aesthetic and methodological heritage to the last half of the nineteenth century and the first several years of the twentieth. Although the gumoil method is unabashedly new, it was nonetheless constructed logically and nostalgically from premodern components that eminently suit it now for making pictures that are somewhat reminiscent of its antecedents.

Important transformational events took place during the early years as people with powerful artistic missions moved photography, quite deliberately, away from being (only) a brilliantly accurate method for making records of routine human events and scenes from nature. These artist-activists formed complex visual impressions and perceptions that paralleled those of many then-current painters. They avidly sought out or modified for themselves an array of technical methods that helped them make the kind of prints that evoked special feelings about the subjects captured by their lens. They were really struggling to move beyond an objective record to a more personal and subjective interpretation of reality.

The technological novelty of photography early on could give ordinary people their own as well as their family's portrait without a painter. As the years went by, box cameras, film, and commercial processing became ever cheaper and easier. It was wonderful, it was magical. It operated synergistically with the emergence of a large middle class, which valued and purchased the new inventions and conveniences. But the mass appeal and availability of photography tended then, as now, to work against its being transformed into a way of making art. Sometimes the

art that was made worked, but too often it was banal and sentimental. To our modern eyes, trained by the hard edges of journalistic and political art, some of it looks downright treacly.

No results, good or bad, were achieved with the premodern methods without a great deal of solitary effort in the preparation of materials and in print manipulation. In the 1880s, a small number of photographers began to take themselves quite seriously as artists, and they wanted to be taken seriously by those who defined acceptance in the world of art. They became increasingly exasperated with many of their professional colleagues who produced stilted studio poses. They also became nauseated at highly mannered compositions from nature in which the view was always perfect, each twig in place. Nature itself and humans in nature were imperfect, so why portray them as if they weren't? The technologies of camera and film were also rapidly improving, and this tended to complement art photographers' increasingly conscious aversion to stagy pictures.

Still, popular photography was then and is now the vastly more important highway network on the photographic road map, and art photography is only a country byway. This is true by any measure. In the 1990s, very few in the world of commerce try to appropriate fine art photographic images, unless one considers the small upscale markets that capitalize on images by photographers like Avedon, Horst, and Warhol. On the other hand, however, one can scarcely overlook how excited gallery and academic photographers have become in recent years about making, or appropriating, art from the dreariest icons of everyday life or from the horrors of street, industrial, and political conflict. Whether these snapshot bits work as art is almost beside the point. That's where a great deal of the energy and thrust is. From the early days, photography was seen as a commercially viable cluster of potential enterprises (subsequently encompassing such diverse applications as industry, education, journalism/publishing, advertising, studio/school portraiture, and the vast photographic product market).

Three artistic movements in photography's premodern period, not entirely separable even in retrospect, were known as naturalism, pictorialism, and Photo-Seccession. They emerged chronologically in that order, but any dividing lines are necessarily fuzzy. Each movement was attempting, in its own time and fashion, to bring a special vitality and acceptance to the photographic image and to promote photography as a critically legitimate art form.

A century or so later, the public, art critics, and photographers themselves are faced with many of the same challenges plus some new ones. The central historical and modern dilemma is a double-sided one that photography may never resolve. First, still photographs on film or videotape are infinitely reproducible by conventional, modern printing methods. This hardly appeals to collectors unless the prints are strictly editioned. It should be noted that most premodern processes generally escape this drawback. The second dilemma, of course, is that anyone can take photographs, with or without elegant equipment, and every now and then come up with a brilliant result.

Virtually no artist, amateur or professional, can draw a picture of Albrecht Dürer quality, but several someones with a decent camera can quite conceivably produce an Edward Weston–quality photograph and even print it properly on commercially available gelatin silver paper with a little darkroom experience. This is the indisputable fact of modern, technologically enhanced life. Truly, this is what technology is ultimately all about—the reliable transference of great power and skill to people with little. This will be an ongoing dilemma for those who want to acquire contemporary art because, as the medium and the available imagery are increasingly mastered by electronics and machinery, the final piece of art is that much more easily produced without handwork.

There is a troubling third factor that is not limited to the field of photographic art: the manifest reluctance of many academic artists and other art commentators when expected to define criteria for artistic judgment. These arbiters of taste face

daily the productions of students, colleagues, and exhibiting artists but are often hesitant to judge. Perhaps they are heeding Matthew's New Testament injunction, "Judge not, that ye be not judged." Or they may hesitate because they are anxious about being politically and/or aesthetically out of step with the times. Mostly, they equivocate and try to say positive things about how stimulating or provocative a given piece is if it is sufficiently offensive or peculiar. As art, and as photographic art in particular, has moved toward a self-justification that invokes theoretical concepts (usually political and mostly half-baked) rather than craft and composition, critical observers seem to have become increasingly reluctant to supply the candid assessments art requires as much as science does.

Sadly, novelty and provocativeness are everything to many critics and collectors (perhaps these characteristics are easier to judge) while other qualities seem less important. One can imagine an Ansel Adams, in the 1980s or 1990s, pursuing his apolitical nature photography, beautifully printed, in a "conceptually correct" university art department, or perhaps Eliot Porter or one of the Westons. In all likelihood, they would be hounded into conformity or out of the program. As art itself has become judgmental, its judges have become blandly permissive. But if the art itself is nonjudgmental and merely well composed and beautiful, the judges are likely to be severe—e.g., "This work is made well but seems to have nothing to say." Still worse, they may find it uninteresting and undeserving of comment. This overview has omitted the issue of scrutability. If a body of work is sufficiently inscrutable, judges are able to declare themselves fond of that, too.

Around 1885, the naturalists (Peter Henry Emerson himself and just a few others) burst into the consciousness of photography. Unlike their predecessors, they were vastly less interested in the twig than the tree. They were more concerned with affective light in the scene rather than with effective lighting or precisely graded tones. Like impressionistic painters, the naturalists in their own fashion were trying to make the image cor-

respond to what they thought the eye transmits neuronally to the brain for further processing. However, Emerson was critical of the impressionistic painters because he thought they were hoodwinking us, the viewers, into seeing something rather more than we did. Emerson wanted his photographs to show just as much as the human eye sees in a flash, no more and no less. He believed that there should be in good photographs a point of fixation with its periphery less focused. Posed high art and other contrived scenes of people and nature he frankly despised. Those of his naturalistic persuasion weren't always clear on what all this meant and became obsessed with how an image focuses and falls upon the retina and the means by which this might best be rendered in photographic terms. Unfortunately, a good deal of his subject matter was boring, well seen or not.

Despite, or perhaps because of, his preoccupation with the physiology of perception, the founder of naturalism, sometimes alone and sometimes with his partner Goodall, was at times able to photograph gorgeously satisfying natural scenes of English countryside and seaside and make stunning platinum and gravure prints on matte surfaces. He frankly hated glossed prints. Inspection of many of the prints does indeed reveal a "point of fixation" that is in fairly clear focus, with surrounding areas somewhat blurred, just as it was supposed to occur naturally in the human optical system. His pictures were posed, to be sure, but this was achieved with studied naturalness, a nice oxymoron. Emerson was always an intemperate fellow, apparently, and in 1890, he abruptly repudiated photography as an art form even though he had earlier promoted the idea with great vigor. He also targeted the impending renaissance of gum bichromate color printing as particularly despicable. He had this attitude even though gum with soluble pigment and its potential for printing enhancement permitted one to emphasize art and deviate from straight photography. Nancy Newhall's monograph (1975) on Emerson is extremely helpful in giving us an understanding of this complicated man, his art, and his times.

The naturalist school seems then to have blended harmoniously into pictorialism, its more vigorous successor movement and one that spanned Europe and America in several sub-groupings. At the distance of a century, the transition looks natural and logical, but at the time, there were nasty words and plenty of injured feelings. Photographers talked and wrote a lot about each other and each other's work, and they did so with far more candor than they do today.

Pictorialism adopted the naturalistic approach to photographing and printmaking, at least roughly speaking, but added to it the pictorialists' willingness and enthusiasm to experiment with all papers, pigments, surfaces, and processes that came to hand. They were less doctrinaire, less concerned with what was right, and far more concerned with what was artistically satisfying. They employed combination printing, the use of several imaging techniques, one atop the other in registration. Gum bichromate printing had returned after many years of being ignored. As a technology, it contributed depth, textures, and colors in an aesthetic quantum leap for fine art photography. Indeed, the Frenchman Robert Demachy (using gum first, moving to oil prints later on) and others were increasingly radical in their fight for this new approach. Art photography became virtually dominated, according to Crawford (1979, 91), by the printing medium itself and therefore by the virtuosity of the printer.

In this era, great activity developed in the relatively new oil and bromoil printing methods, both of which later became transfer processes that permitted virtually identical multiple prints. The early oil methods attracted enthusiastic adherents precisely for their capacity for manipulation (shadow densities, details, and highlights could be added or subtracted at will, and were). Not that this was particularly easy. Oil and bromoil, like most of the premodern processes, were extremely labor-intensive, with much trial and error. Often, the pictures—and they are best viewed at fairly close range—seem to hover somewhere between photography and painting or drawing. Both oil and

gum printing could yield a picture that looks like a charcoal sketch while retaining an unmistakable photographic quality. Exemplars of the movement include Demachy, Kühn, and the early Steichen.

The men and women doing exciting work in photography were aware of the parallel currents in painting, and of the impressionists and postimpressionists in particular. As both fields moved away from the early preoccupation with precision and focus, they became, for a few years, rather like each other: a collection of strokes and blotches up close, but when looked at as a whole, for just a glance, the result was pleasing for at least two reasons. First, it satisfied the (apparently) intrinsic need to reexperience everyday visual events as we actually see them. Second, it provided a charge of emotion, so often possible only if precise details and focus are absent from the stimulus. It provided an opportunity for viewers to project something of their own cognitive life, conscious and otherwise, into the work, to make a bond with the image. A good picture often is "good" precisely because it does this for a significant number of people who look at it. (If it does this for too many people, and especially if the emotions evoked are too sentimental, then the work is sooner or later dismissed as kitsch.)

Naturalism and pictorialism were primarily European. The Photo-Seccession movement, announced by Stieglitz contemporaneously with his first issue of *Camera Work* in 1903, was American in essence. Many of its participants and leaders had first photographed and made prints in the pictorial style but were ready to move on. From a modern perspective, there is not always a lot of difference between the two approaches. In both, there was an emphasis on soft images laid interactively on matte papers (interactive in the sense that the texture of the paper helped to define the texture of the print itself, something that gumoil also capitalizes on). Hues were generally in soft blacks, warm charcoals, or browns, and the coloration, when it occurred, was gentle and understated. The Photo-Seccessionists

eschewed steely or glossy blacks and formed something of an intellectual alliance with impressionism and postimpressionism in the world of painting.

The Photo-Seccessionists were an overlapping, American spin-off from the pictorialists, really a kind of club, with bylaws and dues of five dollars per year. The movement became famous for the publication of a quarterly magazine called *Camera Work* from 1903 to 1917. Many of the original photographs published there have been lost and only exist today on the pages of the magazine. Other comparable groups were forming at more or less the same time in Vienna, England, and Paris. The original Council of the Photo Secession included some very well known names: Stieglitz, of course, but also Frank Eugene, Gertrude Käsebier, Clarence White, and Edward Steichen. These were some of the greatest photographers of the early twentieth century. Stieglitz was unusually influential because of his organizational abilities and his discriminating dedication to photography collecting. Weston Naef's book (1978) is especially useful for an understanding of Stieglitz's range and taste.

Photo-Secessionism was an explicitly radical movement seeking to break new ground for its adored but very controversial medium. Around the same time, there was formed in England a group called the Linked Ring that had many of the same objectives. Members of both groups were excited about the potential of photography as art and felt alternately ignored and besieged by the painting world (real art) at one pole and by popular photography (everything but real art) at the other. By the turn of the century, the acceptance and success of impressionism in painting were sweeping the consciousness of the Western Hemisphere, and photography was increasingly being seen, because of the newly portable cameras and roll films, as something that burghers did on the weekends with their families. There was a good deal of truth to this perception. The American and European photographic societies sponsored exhibitions and competitions with the intention of installing photography as a legitimate form of artistic expression.

In retrospect, painting seems to have won, and photography, fractious and fractionated, has lost. Of course, it was inevitably a losing battle. The painters and critics turned up their noses at photography as art, and so, not surprisingly, did the burghers. After all, something they could do easily at the beach by pressing a button hardly deserved their patronage in the galleries. As recently as 1954, the director of the Victoria and Albert Museum wrote dismissively to the great English pioneer of modern photography, Roger Mayne, that photography was "a mechanical process into which the artist does not enter" (*British Photography*, 1988). Unblushing ignorance of this magnitude will, and perhaps should, yield to enlightenment only slowly. Prices paid at auction and in galleries are an indicator that, until recent years, photographic prints have not been highly desirable for collecting. Weston Naef, in *The Collection of Alfred Stieglitz* (1978), documents acquisition prices paid by Stieglitz for his collection in the early years of the century. They were humble.

The jump from then to now is almost a warp in time. Prices and interest are up for both modern and classical photography. Popular photography, as any reader of the profitable photography magazines can attest, carries through a theme that emphasizes, above all, the glitz of equipment, supplies, and optics. Alongside these ads and promotional articles are beautiful high-tech portfolios. Popular magazines are likely to be concerned with topics like focal sharpness, precision of color rendition, and lighting methods and measurement. These are helpful topics for modern photographers, hobbyists, and commercialists—for almost everyone, in other words, but often beside the point for those who would make pictures by the premodern processes. Printers/photographers seeking alternative methods are pretty much on their own, with just a few books on the subject, a rare article now and then in the popular press, a bit of university-level interest, and some excellent suppliers (see the Annotated Suppliers List at the end of this book).

Even though gumoil is a modern development, it belongs conceptually and emotionally with the more archaic methods.

Had it been available at the time, however, there is little doubt that photographers from Demachy to Steichen would have been attracted to it because it is highly manipulable, infinitely variable in terms of colors and contrasts, and it can produce anything from a straight photograph to a painterly image to a surreal one. Its appeal to present or future photographers and printers remains to be seen, but this book's purpose is to make gumoil understandable to and feasible for people with basic darkroom and photographic skills.

One can only speculate how gumoil and, for that matter, the other premodern processes may ultimately be reconciled with modern photography. Modernists at this moment are enthused with electronically generated images, and this may produce a total renunciation of conventional film, chemistry, and silver paper printing, to say nothing of the more ancient processes. Conventional silver printers as well as devotees of video and copy machine art may react negatively against printmaking methods that require messy oil paints and linseed oil, noxious and skin-degrading bleach, sticky gum arabic, toxic bichromate, and all the other untidy, time-consuming steps of gumoil. Gumoil rarely yields a satisfactory and usably dry print in less than three weeks from film negative to finished work. The final print is typically one of a kind, often a true monotype or one that is certainly difficult to reproduce exactly.

Every generation of photographers embraces new technologies, partly because of labor savings, partly because of a love of novelty, and partly because the results are beautiful or striking. At the same time, crosscurrents have existed in every generation for a return to the old technologies and crafts because of the beauty of the early pictures. Happily, there are photographers who persist in producing fine images with nearly forgotten methods such as tintype, tricolor carbro, or albumen-coated papers. Others are making platinum and palladium prints on hand-coated papers, sometimes with old view camera technology but always printing by contact negatives. The idea of all this is not to make pictures just like the old masters with some kind

of devotional value placed on labor and inconvenience. Rather, it is to make pictures by taking advantage of the special characteristics inherent in earlier processes but modifying those processes to make the pictures as well as before and often more practicably.

Gumoil as a process has been intensively explored by the author but by few others. Consequently, it is a limited story with a fairly clear beginning but an uncharted future. Several exciting and satisfying pictures have been made with the process, but better ones are surely yet to come as others take hold of the method, modify the concepts, and stretch it. Formulas, rules, and regulations are laid down in the following chapters. They should be regarded as guidelines, not absolutes. When advances in gumoil are made, they will come by accident and by challenging the rules.

NOTES

1. Personal communication: Diana Gaston, curator of the Art Museum of the University of New Mexico, Albuquerque; and Pamela Roberts, curator of the Royal Photographic Society, Bath, England.

of the size desired for the ultimate print. In this book, the paper prints were either about 8 inches × 12 inches or 10 inches × 10 inches before they were rephotographed onto color transparency slide film prior to publication.

To get significantly larger prints than these sizes may be a practical problem for some workers since this requires a correspondingly larger laboratory space, as well as larger trays, film sheets, contact printers, and so forth. If one wanted to work in a 16- × 16-inch or 16- × 20-inch print format, or even bigger, it also might be preferable, or even necessary, to start with "medium format" film negatives such as 6 centimeters × 6 centimeters, 6 centimeters × 7 centimeters, or 6 centimeters × 4.5 centimeters in order to get sufficient resolution when enlarged onto big sheets of film. This is less difficult for those photographers who already have a medium format camera such as the Pentax 67, the Mamiya 6, the Hasselblad, or one of the 6 × 4.5 Bronicas or Pentaxes.

There are, then, some constraints on final size determined by the initial size as well as the quality of the original negative. As explained below, choice of film (i.e., its relative graininess and tonal characteristics) swells in importance as the size of the desired enlargement increases in relationship to the size of the original. The logistics of very large prints suggest that there may be a point of diminishing returns requiring, as it would, correspondingly large sized pieces of ortho litho film, contact printing frames, and darkroom equipment. Still, these parameters have not been tested, and it may turn out that rather large prints in gumoil can be done effectively. It is equally true that the parameters of smallness have not been explored by this author either. Gumoil miniatures are consequently unknown, but there is no reason to avoid attempting to make them.

There are challenging aesthetic considerations when choosing one negative from an assortment of negatives for gumoil printing. First, the process should not be used to overwhelm the subject chosen for printing. That is, printing by gumoil should enhance the image rather than merely advertise the method's

of the size desired for the ultimate print. In this book, the paper prints were either about 8 inches × 12 inches or 10 inches × 10 inches before they were rephotographed onto color transparency slide film prior to publication.

To get significantly larger prints than these sizes may be a practical problem for some workers since this requires a correspondingly larger laboratory space, as well as larger trays, film sheets, contact printers, and so forth. If one wanted to work in a 16- × 16-inch or 16- × 20-inch print format, or even bigger, it also might be preferable, or even necessary, to start with "medium format" film negatives such as 6 centimeters × 6 centimeters, 6 centimeters × 7 centimeters, or 6 centimeters × 4.5 centimeters in order to get sufficient resolution when enlarged onto big sheets of film. This is less difficult for those photographers who already have a medium format camera such as the Pentax 67, the Mamiya 6, the Hasselblad, or one of the 6 × 4.5 Bronicas or Pentaxes.

There are, then, some constraints on final size determined by the initial size as well as the quality of the original negative. As explained below, choice of film (i.e., its relative graininess and tonal characteristics) swells in importance as the size of the desired enlargement increases in relationship to the size of the original. The logistics of very large prints suggest that there may be a point of diminishing returns requiring, as it would, correspondingly large sized pieces of ortho litho film, contact printing frames, and darkroom equipment. Still, these parameters have not been tested, and it may turn out that rather large prints in gumoil can be done effectively. It is equally true that the parameters of smallness have not been explored by this author either. Gumoil miniatures are consequently unknown, but there is no reason to avoid attempting to make them.

There are challenging aesthetic considerations when choosing one negative from an assortment of negatives for gumoil printing. First, the process should not be used to overwhelm the subject chosen for printing. That is, printing by gumoil should enhance the image rather than merely advertise the method's

2

Images That Work,
Images That Don't

The gumoil method is forgiving in many respects and has an inherent capacity to make attractive prints across a fairly wide range of images. There seem to be some practical and aesthetic limits, however.

Practically, the process requires an enlarged positive that must be placed between the light source and the light-sensitive gummed paper. The contact printing of bichromated gum surfaces requires a very strong light source such as the direct unclouded sun, an arc lamp, or a suntanning lamp held just above the printing surface. It is useless to use an enlarger or some other weak source for the purpose.

Unless you are using a large transparency contact printed from an original film negative (say, 8 inches × 10 inches) from a view camera, this means that a relatively small black-and-white negative (35 millimeters or 6 centimeters × 6 centimeters, for example) will require enlargement onto a piece of specialized film

of devotional value placed on labor and inconvenience. Rather, it is to make pictures by taking advantage of the special characteristics inherent in earlier processes but modifying those processes to make the pictures as well as before and often more practicably.

Gumoil as a process has been intensively explored by the author but by few others. Consequently, it is a limited story with a fairly clear beginning but an uncharted future. Several exciting and satisfying pictures have been made with the process, but better ones are surely yet to come as others take hold of the method, modify the concepts, and stretch it. Formulas, rules, and regulations are laid down in the following chapters. They should be regarded as guidelines, not absolutes. When advances in gumoil are made, they will come by accident and by challenging the rules.

NOTES

1. Personal communication: Diana Gaston, curator of the Art Museum of the University of New Mexico, Albuquerque; and Pamela Roberts, curator of the Royal Photographic Society, Bath, England.

novelty. This becomes an immediate question of taste and judgment for which there are many solutions, no doubt. In the evolution that necessarily accompanies learning to print in a completely new medium, each individual will undergo significant shifts in personal printing style and preferences. If you are not well versed in painting, the use of colors, and the various effects colors have upon each other, it may be helpful to learn something about the discipline. Michael Wilcox's *Blue and Yellow Don't Make Green* (1987) is extremely useful for a better understanding of color, color mixing, and the vast range of different colors that exist. Although color is a bit ahead of the story of gumoil, it makes sense to begin thinking about possible colors and their interaction when sitting before an array of black-and-white negatives and contact sheets.

Painting, drawing, and photography are synergistically related for many people, and practice at any one seems to pay dividends in the others. Artists use each technique to translate what they see onto a two-dimensional surface for others to see. Drawers often paint, and painters usually draw, but they may not make photographs seriously. Conversely, photographers, especially those who adore technology and assume they "can't draw" or "can't paint," can improve their picture taking and making when they start drawing and painting.

The best negatives for gumoil printing are those with a substantial amount of gradation in the intermediate tones and full extension, on either side, to values that will produce deep blacks in the shadows as well as whites in the high light areas. In zone system terms, this means the best negatives will be those with density values distributed across all of the zones (see Johnson, 1986, for a good discussion of the zone system). Poor negatives for gumoil are those with only a few zones, no matter how or where the zones are distributed.

Negatives that are extremely high in contrast and offer little in the way of softly graduated tones are generally unsuitable for the gumoil process unless one wants to produce extreme effects comparable to a line drawing or other high-contrast images such

as might come from traditional etching, serigraphy, and wood-block printing. In other words, it is certainly possible to use gumoil as a printing method to produce a variety of nonphotographic effects, but they are not the subject of the present book.

Low-contrast images can often be very effective in other photographic media such as platinum, palladium, and to some extent, even silver. They have produced unsatisfactory results, however, in gumoil. In monochromatic gumoil, a low-contrast picture tends to be smeary and becomes lost. In polychromatic gumoil, there is an insufficient range in the gum's thickness for the etching baths to achieve good separation of colors.

The intermediate- to higher-contrast negative, leaving aside the merits of the image itself, can often be converted into the ideal positive transparency for printing in gumoil. Such a negative would be one whose blacks are good and dense without eliminating useful detail, whose intermediate gray tones are spread over a wide range, and whose clear spaces (shadow areas) still have some definite information within them. Thus, one wants a negative (and ultimately, a positive transparency) possessing values from 0 to IX with intermediate tonal values well represented. Because the gumoil printing process is itself inclined to produce high-contrast values, it is better (or at least easier) to begin with film images of moderate contrast. Reproduction of detail is a separate issue. The process is perfectly capable of reproducing fine detail, even on fairly heavily textured papers, though it will do detail work somewhat better on smooth ones.

Another way of assessing the suitability of a negative is to look for what might be called the modeling of rounded or tubular figures in a picture. The picture *Elie Beeches* (Color Plate 1 in gumoil and Figure 2.1 in silver) has the sort of modeling that lends itself well to the gumoil process. The trunks of the trees, together with the lighting on the original scene, are captured in their rounded fullness. It helped a great deal in the picture

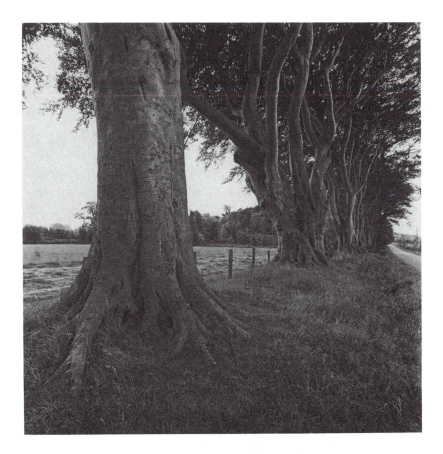

Figure 2.1 *Elie Beeches* (Scotland). Silver

taking that the light was Scottish North Sea cloudy-bright and that the trees were beeches, whose bark tends to be luminous even in poor light. A negative of the same image in either flatter or more contrasty light would have produced a far less satisfactory print.

For present purposes, it is assumed that a novice gumoilist will begin with black-and-white negatives from any of several panchromatic films. These may be as small as 35 mm or as large

as the largest plate film from a field camera. An excellent and fast (400 ASA) film in 35-millimeter format is Fuji's Professional Neopan. The Kodak T-Max films earn a respectable second place. Kodak Plus-X and Tri-X are also quite satisfactory. Fuji Neopan, even in its 35-millimeter size, is so good that it allows a photographer to make high-quality, tonally well graded, hand-held shots of scenes that only a few years ago would have required much slower film and a tripod. Unfortunately, Fuji Neopan is hard to find in this country and often unavailable in 120/220 format. It is best when developed in HC110, dilution B, with a minute or two added to the recommended time at 70 degrees. This is assuming the film was exposed to yield good details within the shadows set on zone IV. A 1 degree spot meter and a zone system decal (available from Fred Picker at Zone VI Studios, Inc.) will provide exposure time and aperture.

What if there is no negative but a halftone print of some sort is available? This presents no great problem, providing the print has good tonality. Put it through a copier onto a sheet of transparent material or plain, very thin white paper. With some experimentation, a positive with adequate gradation of tone can usually be produced. The problem with photostatic copiers is that they lean toward high definition and away from tones. Positive printing material can also be obtained from color prints. Longer contact printing exposure times will be needed for thin paper positives.

Transparent positives can be made from black-and-white film negatives, black-and-white prints, color prints, or color slides.[1] For that matter, positive transparencies can be made from magazine or newspaper photos. Achieving an adequate tonal range will be the challenge. With that stipulation, the gum-oil process has the capacity to print photographically from any continuous tone image.

The gumoil process lends itself especially to evoking at-mospheric qualities. Moody landscapes, dramatically individual trees or tree clusters, dreamy woodlands, desolate factories, deteriorated cemetery sepulchres, frame-filling portraits, and

simple clapboard or adobe churches are all subjects that have been treated successfully in gumoil. The process seems much less suited to action pictures, busy pictures, snapshots of animals, and scenes with a great deal of horizon and distance in them. Whatever the subject, gumoil seems to require a strong, defining central feature. A perfectly pleasant image, on the other hand, of a seaside, an interesting rock formation, or a lively family group may work well enough in conventional silver gelatin printing, but it is somewhat less likely to be interesting as a gumoil.

If one decides to continue working in gumoil, great emphasis inevitably comes to be placed on the image and negative selection process. It is terribly discouraging to invest the effort and time required to make a final print only to realize that it has all been wasted on an image and/or a negative that was unsuitable from the outset. (All, that is, except the important learning that comes from the experience.) Time taken at the front end of the selection process is a good investment if one uses it for reflective critical thinking. Selection behavior itself is an acquired skill and could be plotted as a learning curve.

NOTE

1. With a special holder available for each enlarger model, color slides can be projected through the lens onto black-and-white ortho litho film and developed in the manner described later. This procedure will produce a large negative that can be contact printed under the enlarger's light onto a second sheet of ortho litho film, resulting in a *positive* transparency of exactly the same size.

MAKING LARGE POSITIVES

Gumoil is a contact or direct printing process requiring a piece of film on which the image is the same size as the desired size of the final print. Kodak Professional B/W Duplicating Film SO-339, Kodak 2575 Direct Dupe, and high-contrast litho films such as Aristo Premium Litho, Kodalith, and Freestyle's ortho litho are several and diverse films that come in sheets of suitably large sizes. The advantage of duplicating film is that it allows a direct transition from continuous tone negatives to continuous tone *enlarged* positives or negatives, but these films are relatively expensive, and in the author's experience, they do not regularly yield the contrast necessary for good gumoil prints.

Ortho litho films, which are cheaper than duplicating films, are manufactured for use in commercial lithographic printing processes and are generally used to render images in absolute blacks and whites. They are beautifully suited for line drawings or dot matrix images. Very important for the purposes of gumoil and for other premodern photographic printing processes, however, ortho litho films can also produce graduated tonal ranges when developed properly for that purpose—that is, when developed differently than the manufacturers intended. Refer to Robert Hirsch (1991) for a thoughtful discussion of copy films. For an easy and cheap method of using ortho litho film for positive and negative transparency enlargements, proceed as described in the following sections.

EXPOSURE

The objective for printing in gumoil is first to make a large positive image on an otherwise transparent sheet of film. It is directly from the enlarged positive that a final print on good-quality watercolor paper, smoothly coated with sensitized gum arabic, will be made. The first step, after choosing an appropriate black-and-white negative to enlarge, is to examine its char-

MAKING LARGE POSITIVES

Gumoil is a contact or direct printing process requiring a piece of film on which the image is the same size as the desired size of the final print. Kodak Professional B/W Duplicating Film SO-339, Kodak 2575 Direct Dupe, and high-contrast litho films such as Aristo Premium Litho, Kodalith, and Freestyle's ortho litho are several and diverse films that come in sheets of suitably large sizes. The advantage of duplicating film is that it allows a direct transition from continuous tone negatives to continuous tone *enlarged* positives or negatives, but these films are relatively expensive, and in the author's experience, they do not regularly yield the contrast necessary for good gumoil prints.

Ortho litho films, which are cheaper than duplicating films, are manufactured for use in commercial lithographic printing processes and are generally used to render images in absolute blacks and whites. They are beautifully suited for line drawings or dot matrix images. Very important for the purposes of gumoil and for other premodern photographic printing processes, however, ortho litho films can also produce graduated tonal ranges when developed properly for that purpose—that is, when developed differently than the manufacturers intended. Refer to Robert Hirsch (1991) for a thoughtful discussion of copy films. For an easy and cheap method of using ortho litho film for positive and negative transparency enlargements, proceed as described in the following sections.

EXPOSURE

The objective for printing in gumoil is first to make a large positive image on an otherwise transparent sheet of film. It is directly from the enlarged positive that a final print on good-quality watercolor paper, smoothly coated with sensitized gum arabic, will be made. The first step, after choosing an appropriate black-and-white negative to enlarge, is to examine its char-

3

Enlarged Positive and Negative Transparencies

This chapter begins your practical introduction to those skills that will culminate in a full understanding of the gumoil process and its variants. Systematic progression through the book will produce the most efficient learning and fewest mistakes in printing. Some readers will find that proceeding this way makes it less fun, and their motivation may lag. Motivation is essential because the gumoil process itself takes so much physical effort and time before a good print can be made, even when you know how. Work your way systematically through Chapters 3–8, performing the operations described in each. This will result in your being able to produce a polychromatic print with the least pain.

simple clapboard or adobe churches are all subjects that have been treated successfully in gumoil. The process seems much less suited to action pictures, busy pictures, snapshots of animals, and scenes with a great deal of horizon and distance in them. Whatever the subject, gumoil seems to require a strong, defining central feature. A perfectly pleasant image, on the other hand, of a seaside, an interesting rock formation, or a lively family group may work well enough in conventional silver gelatin printing, but it is somewhat less likely to be interesting as a gumoil.

If one decides to continue working in gumoil, great emphasis inevitably comes to be placed on the image and negative selection process. It is terribly discouraging to invest the effort and time required to make a final print only to realize that it has all been wasted on an image and/or a negative that was unsuitable from the outset. (All, that is, except the important learning that comes from the experience.) Time taken at the front end of the selection process is a good investment if one uses it for reflective critical thinking. Selection behavior itself is an acquired skill and could be plotted as a learning curve.

NOTE

1. With a special holder available for each enlarger model, color slides can be projected through the lens onto black-and-white ortho litho film and developed in the manner described later. This procedure will produce a large negative that can be contact printed under the enlarger's light onto a second sheet of ortho litho film, resulting in a *positive* transparency of exactly the same size.

acteristics under enlargement on the easel. At this point, cropping (with the enlarger) can occur, if needed, and a set of exposure values is chosen.

A reasonable place to begin is between F8 and F11 combined with an exposure time of 15 or 20 seconds using the ortho litho film available from Freestyle in Los Angeles (see the Annotated Suppliers List at the end of this book). It may be desirable to work with test strips, especially if you are a beginner. Eventually, you will acquire the ability to read the negative and set the exposure values. Incidentally, the best easel is one of fixed size with raised sides and a heavy stabilizing bale. Such an easel holds the film snugly and uniformly—a very helpful feature, especially if the film is to be punched and registered on pins taped to the easel.

It does not seem to matter which side is exposed, emulsion or back. Dodging and burning, as you might with a paper positive, is fairly easy to manage but should probably be postponed until your overall level of expertise with the method is greater. In any event, the negative was carefully and specifically chosen precisely for its good balance and tonal range. It should require little, if any, manipulation to produce a positive that will lead to a fine gumoil print. If a film positive is (accidentally) produced with very high contrast, an image that tends to all-or-nothing tones, it will result in a disappointing gumoil print, as mentioned in Chapter 2. The print will invariably lack subtlety and tonality, and the gum surfaces will lack the capacity for the bleach etching that enables the printmaker to achieve differential shading and coloring.

The best positive transparency, for gumoil purposes, usually has slightly more contrast than one might want in an ideal finished silver print. It bears repeating that the gumoil process itself needs a somewhat contrasty positive because some of the film positive's subtlety will be lost in the course of color applications, bleach etchings, and other manipulations. These recommendations are for a middle-range negative because nothing

can save a negative at either of the two extremes of ultrahigh and ultralow contrast.

After a little experience with the film development process, it should become fairly easy to judge film positives for their potential printing qualities. Once this happens, it is preferable to remake weak or failed positives immediately until one of them meets the printer's evolving subjective standard rather than waiting until another day. On that other day, when it comes, temperatures, solutions, and other variables will be so different that the advantage of making immediate successive approximations toward the ideal will have been lost.

DEVELOPMENT

It will be assumed that you will use Freestyle's ordinary ortho litho, the preferred film because it is priced reasonably and comes in convenient sheet sizes (i.e., dimensions that fit enlarging easels). See the Annotated Suppliers List for the film and the A + B developer designed for litho-type film. If the A + B developer is used undiluted, it will result in absolute black or white nontonal images, as the manufacturer intended. If the A + B developer is diluted with water, however, tonal ranges corresponding approximately to the enlarging negative will then emerge on the exposed film. *The A + B developer increases its ability to reproduce tonal values as its dilution is increased,* but the solution's lasting power is dramatically reduced in proportion to the extent of dilution.

Consider Table 3.1, which lays out the dilutions needed to produce varying degrees of contrast in a positive ortho litho film, assuming an average-contrast negative film as a starting point. These are rough, empirically derived values for this writer and his studio and a particular water supply. As a printer, you will have to establish your own values.

Temperature is not critical, but solutions at approximately 70 degrees Fahrenheit, plus or minus 5 degrees, work well. What

Table 3.1 Ortho Litho Film Contrast Values and Developing Chemistry

Contrast Result	Dilutions
Black or white (no tones)	1 A + 1 B only, no added water
Medium to low (fair tonality)	1 A + 1 B + 9 parts water
Low	1 A + 1 B + 15 parts water
Lower	1 part Dektol stock + 8 or 10 parts water
Lowest	1 part HC110 stock (dilution B) + 4 parts water

is important is to keep all baths at similar temperatures to prevent reticulation of the film's emulsion that sometimes occurs when a film is shifted rapidly from a bath at one temperature to a bath at a significantly different one.

A sodium vapor safelight with two filters (available from Zone VI Studios) seems to protect well against fogging if it is several feet away from the developing film. You definitely need to see the film as it develops. The greater the dilution of the developer, the greater the time required for proper and full development. Be prepared to wait 4 or 5 minutes, with occasional gentle agitation, for the low-contrast dilutions. The most likely error at this stage is to remove the film from the tray before full development occurs. Because of the film's emulsion characteristics and the poor ambient lighting, a film image will appear too dark in the developer when it is actually just about right. Experience is the only satisfactory teacher in this learning process. Covering the developing tray, even in safelight, is a good idea.

Use white trays for development because black ones render the transparent film impossible to read. A conventional stop bath is recommended for about 30 seconds followed by a film hardener-fixer for 2 or 3 more minutes until it clears completely.

Wash for 15 minutes unless a hypo clearing bath is used to shorten the time. Developed film can be left in a water-filled holding tray if you wish to wash all the film sheets at one time. After washing (and perhaps a bath in a wetting agent), the film sheets need to be supported by clips and hung vertically by a corner without touching each other. After thorough drying, the sheets can be usefully stored and protected from dust and handling in clear vinyl holders. With a marking pen, it is helpful to write development notes directly on the holders or on the margins of the film sheets.

The diluted developer exhausts rapidly. A satisfactory method of replenishment is to have a container of premixed, undiluted A + B and another with some warm water at sink side. Assume a medium- to low-contrast developer in a 14- × 17-inch tray. In ounces, that would be 8 of A, 8 of B, and 72 of water. After three pieces of film are separately developed, remove 3 ounces of the tray solution and add 1 ounce of premixed A + B and 2 of the warm water for *each* subsequent ortho film sheet. If development times slow down dramatically, add a bit more A + B but not so much that the positives lose their tonal range. Leave a thermometer in the tray and keep the fluid around the 70 degree Fahrenheit range, plus or minus 5 degrees. The contents can be warmed or cooled if necessary by standing a jar of hot or iced water in the tray. It is easiest to use a tray that has an area significantly larger than the film itself. Drain the tray after a total of 8 sheets or so.

As indicated in Table 3.1, it is possible to use developers other than the A + B type. Dektol and HC110 both give satisfactory results, especially in the lower contrast ranges.

MAKING LARGE NEGATIVE FILMS

Virtually every premodern photographic process (other than gumoil printing) requires a direct negative the same size as the final print. Once a high-quality positive has been produced, it is

simple enough to convert it into a negative of comparable quality by carefully contact printing it under the enlarger. The positive can be laid directly over a fresh piece of ortho litho film, and preferably in registration, for potential future use. A later combination printing process may require exact registration (see Chapters 1 and 8).

A typical exposure is around 10 seconds, with no lens at all in the enlarger, merely direct light from an enlarger whose distance from the easel is comparable to the earlier process. Test strips may also be used here. A good enlarged negative can be used to produce high-quality paper prints in a variety of printing mediums such as cyanotype, Vandyke, and gum bichromate. Platinum and palladium, however, require a less contrasty negative.

Large transparencies, negatives or positives, are easy to manipulate. If there are spots and marks, which is often the case when using litho film, these can be bleached with a water solution of potassium ferricyanide, an easily obtained chemical. Blacking out or shading can be added with variously diluted solutions of masking liquids and pastes from an art store, much as a tusche wash is used in lithography, and a totally black mask can be applied to film borders (precisely or with brushing techniques) to create totally black edges on the final gumoil print. Some liquid masks are removable with water. This is preferable to permanent masks. Red lithography tape also works well and is removable. The liquid mask for films is not the same as the liquid latex mask or frisket mentioned in Chapter 8, which is used on the print itself.

Large film sheets should be stored in acetate envelopes. Exposure and development values can be noted on the envelopes or on the film margins.

Most of the papers mentioned have, at least on occasion, produced satisfactory results in gumoil. At this writing, however, the otherwise popular Rives BFK and the Strathmore 400 Series papers have resulted in poor to unacceptable prints and should be avoided. See the Annotated Suppliers List for information on ordering papers.

Gumoil printing, to be successful, requires paper with certain characteristics. One of these is the paper's weight. Nothing less than 140-pound paper seems to hold up, and heavier papers could certainly be used. The weight measure that describes a paper refers to how much one ream, or five hundred sheets, weighs in pounds. This measure is gradually being replaced by grams per square meter (in the case of 140-pound paper, 300 grams per square meter). This is a substantial paper weight but not unmanageable, and it will tolerate the repetition of rubbing, bleaching, brushing, and washing intrinsic to the gumoil process. When oil paint is forced into the paper's open spaces, the next thinner paper, at 90 pounds, no matter the quality, will tend to roll up or accidentally crease. A crease ruins the print. This is not to say that 140-pound paper can't also crease. It can, but with reasonable care, the use of heavier paper will reduce this sort of error. A very meticulous worker might succeed with lighter papers, but there is no obvious aesthetic or practical benefit.

Another important characteristic is the paper's whiteness. Fabriano and Arches, for example, manufacture gorgeous white papers that permit an accurate rendition of the tubed oil colors selected for printing out the image after the latent gum image has been laid down. The use of colored papers is a different matter entirely. One can imagine some circumstances in which a buff or gray paper might be a more suitable background for the chosen colors and image than white. The prints reproduced in this book were all originally created on pure white paper.

A third consideration is the paper's texture. Two basic types of paper surface have been used extensively with gumoil. The first is cold-pressed (designated CP in catalogs). These are papers that possess a noticeable matrix, something like a deli-

Most of the papers mentioned have, at least on occasion, produced satisfactory results in gumoil. At this writing, however, the otherwise popular Rives BFK and the Strathmore 400 Series papers have resulted in poor to unacceptable prints and should be avoided. See the Annotated Suppliers List for information on ordering papers.

Gumoil printing, to be successful, requires paper with certain characteristics. One of these is the paper's weight. Nothing less than 140-pound paper seems to hold up, and heavier papers could certainly be used. The weight measure that describes a paper refers to how much one ream, or five hundred sheets, weighs in pounds. This measure is gradually being replaced by grams per square meter (in the case of 140-pound paper, 300 grams per square meter). This is a substantial paper weight but not unmanageable, and it will tolerate the repetition of rubbing, bleaching, brushing, and washing intrinsic to the gumoil process. When oil paint is forced into the paper's open spaces, the next thinner paper, at 90 pounds, no matter the quality, will tend to roll up or accidentally crease. A crease ruins the print. This is not to say that 140-pound paper can't also crease. It can, but with reasonable care, the use of heavier paper will reduce this sort of error. A very meticulous worker might succeed with lighter papers, but there is no obvious aesthetic or practical benefit.

Another important characteristic is the paper's whiteness. Fabriano and Arches, for example, manufacture gorgeous white papers that permit an accurate rendition of the tubed oil colors selected for printing out the image after the latent gum image has been laid down. The use of colored papers is a different matter entirely. One can imagine some circumstances in which a buff or gray paper might be a more suitable background for the chosen colors and image than white. The prints reproduced in this book were all originally created on pure white paper.

A third consideration is the paper's texture. Two basic types of paper surface have been used extensively with gumoil. The first is cold-pressed (designated CP in catalogs). These are papers that possess a noticeable matrix, something like a deli-

4

Paper and Paper Preparation

CHOOSING THE PAPER

A number of art papers may eventually be found to be suitable for printing in gumoil. Most of the highest-quality papers are intended for watercolor painting, lithography, or silk-screening, and they carry such names as Fabriano, Murillo, Arches, Stonehenge, and Lanaquarelle, to name a few. They are available in large sheets and sometimes in tablets of various sizes. Some come in grades, such as professional quality or student quality, and each sheet is watermarked to indicate its maker and, sometimes, its rag (cotton) content. The better art supply houses publish catalogs that describe the papers they carry. Of these houses, Daniel Smith is outstanding because its frequently issued catalogs provide accurate color photographs of the papers, offer a very large selection and sample packets, and frequently contain excellent articles and charts.

simple enough to convert it into a negative of comparable quality by carefully contact printing it under the enlarger. The positive can be laid directly over a fresh piece of ortho litho film, and preferably in registration, for potential future use. A later combination printing process may require exact registration (see Chapters 1 and 8).

A typical exposure is around 10 seconds, with no lens at all in the enlarger, merely direct light from an enlarger whose distance from the easel is comparable to the earlier process. Test strips may also be used here. A good enlarged negative can be used to produce high-quality paper prints in a variety of printing mediums such as cyanotype, Vandyke, and gum bichromate. Platinum and palladium, however, require a less contrasty negative.

Large transparencies, negatives or positives, are easy to manipulate. If there are spots and marks, which is often the case when using litho film, these can be bleached with a water solution of potassium ferricyanide, an easily obtained chemical. Blacking out or shading can be added with variously diluted solutions of masking liquids and pastes from an art store, much as a tusche wash is used in lithography, and a totally black mask can be applied to film borders (precisely or with brushing techniques) to create totally black edges on the final gumoil print. Some liquid masks are removable with water. This is preferable to permanent masks. Red lithography tape also works well and is removable. The liquid mask for films is not the same as the liquid latex mask or frisket mentioned in Chapter 8, which is used on the print itself.

Large film sheets should be stored in acetate envelopes. Exposure and development values can be noted on the envelopes or on the film margins.

cately embedded weave or slightly canvaslike texture. These surface textures come from the webbing of the rollers between which the pulpy paper is squeezed without heating. The other surface suitable for gumoil is hot-pressed (HP) paper. A smoother, glazed surface is achieved by pressing the paper through hot rollers. The photograph on the back cover was printed on HP paper and all the others on CP paper.

You will need to make a judgment regarding whether a smooth paper will print a particular image better, or better in certain ways, than a rougher one. In some circumstances, HP, or smooth, paper is the better printing surface for gumoil, especially when a finely detailed image is sought. CP paper, however, is generally better for applications in which a more textured, painterly effect is sought. If trace background residues of paint are important aesthetically in the final print, then a more textured paper is indicated. Smooth paper tends to give a more precisely photographic effect and is, perhaps, somewhat easier to manipulate through liquid or tape masking techniques (see Chapter 8).

No significant print quality difference seems to exist between using the watermark side of the paper or its reverse. Fabriano Artistico prints both sides very well in gumoil. Indeed, should one side become spoiled, it is sometimes possible to print again on the reverse, assuming it's been kept clean, by recoating it with more sensitized, unpigmented gum.

In every case to date, the best paper overall for gumoil printing has been Fabriano Artistico, 100 percent rag, CP or HP, in the 140-pound thickness. Like most high-quality papers, it is acid-free and highly archival and is widely available. All the gumoil images in this book were originally printed on Fabriano before being rephotographed.

There are many high-quality papers made in rough (R) texture. This surface is easily distinguished from HP and CP but is probably not suitable for gumoil. At the other extreme, it seems unwise to use the beautiful but fragile papers made of rice or exotic grasses. It is possible to print gumoil images on (un-

sized) stretched canvas and other materials with absorbent surfaces such as unglazed ceramic or unfinished wood and its derivatives, although none, so far, is as satisfactory as paper. In choosing a material, bear in mind that the process demands a surface that not only will accept the wetness associated with coating and developing but must also be able to withstand marathon washing and bleaching, without which gumoil printing cannot be done.

Finally, it is not clear what, if any, contribution the sizing of the papers may make. Sizing is applied to paper to reduce the absorptive power of a paper's surface. Paper can be sized by the manufacturer or you, the printmaker, by coating the paper with solutions of rosin, glue (Elmer's works very nicely), gelatin, or various starches. Fabriano Artistico, the paper of choice for gumoil, needs no additional sizing, and in fact, the paper's natural absorbency is a positive attribute because it is desirable for the oil-based pigments to sink deeply into the fibers while being successfully repelled in the gummed areas. Rives BFK, mentioned earlier as unsuitable, seems to be so because it is too absorbent; on it, gum is an ineffective resist to the oil paint.

In contrast, gum bichromate printing with water-soluble pigments always requires sizing of the paper so that during the development-washing phase, the unwanted colored gum will slough off thoroughly from the picture's white spaces. Without sizing, the picture will tend to become stained from free pigment sinking deep into the paper's tooth. Because gum bichromate printing is often done as a multiple-application process, a question of sizing between registered exposures is frequently raised as well.

In gumoil printing, the paper must have considerable absorptive power or it will tend to repel the oil-based pigment. A paper such as Rives BFK, on the other hand, seems to be so absorptive that it is impossible to clear the oily pigment properly from those portions of the paper that should provide the

white spaces. Perhaps Rives BFK could be sized to work better, but there seems little point to the exercise.

THE COATING

In several lithographic and photographic procedures, a candylike-smelling colloid, known as gum arabic, has long been an essential component. In the gumoil process, a colloidal solution of gum arabic, combined with some potassium bichromate dissolved in water, is used to coat the paper. The resulting (dried) surface is sensitive to light, although vastly less sensitive than the commercial papers coated with silver nitrate, gelatin, or resin commonly found in darkrooms. Gum-coated paper cannot be used under a conventional enlarger, and it can be handled in subdued tungsten room light.

When a sheet of paper, coated with a sensitized gum and dried, is exposed to sunlight, with a large film positive between it and the sun, the coating will harden in direct relationship to the amount of light it absorbs. Clear areas in the film will produce extremely hard gum surfaces on the paper. Dark areas in the film will produce soft and dissolvable surfaces on the paper. Ultraviolet radiation solidifies the sensitive gum and makes it resistant to being washed away by water. On the other hand, those portions of the coated paper that receive little or no light are easily removed by water washing. A final matrix of differentially gummed and ungummed areas results after sun exposure and water development.

The gum that remains after developing and drying will be an unattractive light olive-brown color, and the image will appear, essentially, as a negative in this odd color with white spaces corresponding to the shadows. The purpose of all this is to produce a paper surface that will receive oil pigments in its white (open) shadow areas and reject them in the somewhat

darker (closed) highlight areas. The gummed areas serve as a resist to pigments and in this way can become the lighter parts of the picture, whereas the open areas will receive oil pigments and become the darker parts of the picture. Methods for removing the unattractive gum color are discussed later. Indeed, exploring ways of removing the residual gum led to the discovery that made polychromatic printing possible.

Gum arabic, obtained from the African acacia tree, was once available only in a powder or more granular form because adding water at the point of manufacture made the gum susceptible to mold and decay processes. Gum arabic is easily and cheaply available now in a liquid with a nontoxic stabilizing agent, which means that you do not have to add formaldehyde or the very poisonous mercuric oxide (called for by Scopick as recently as 1991). With one exception, there is little reason to use powdered gum to prepare a liquid. Commercially available gum is generally rated at either 10 or 14 degrees Baumé. This is a measure of the liquid's specific gravity (or thickness, to most of us). Ten degrees Baumé is on the thin side for gumoil. Fourteen degrees is fine for most gumoil applications, but it may turn out that an even thicker solution than this is preferred.

In this event, you probably should have on hand a small supply of gum in powder form. To make a thick gum solution, mix 1 ounce of powdered gum with 1 ounce of water. It should be stirred vigorously and then left alone for 24 hours or so. A uniform syrup will form. Rushing the process does not speed things up as gum dissolves in its own time. Refrigerate. A drop of formaldehyde may be added if the solution is to be kept more than a month, but formaldehyde is likely to make the gum jell in the jar or, alternatively, harden up too much after coating and exposure. With or without formaldehyde, gum arabic preparations sometimes behave strangely. If such a preparation jells, it is usually possible to reliquefy it by placing the container in hot water with stirring. If it is kept without a preservative, a mold will eventually form and the mixture will spoil. In any

case, do not add sensitizer directly to this mixture but save it as a thickener.

For an extra thick coating, mix one part thick syrup, two parts of commercial gum at 14 degrees Baumé, and one part stock sensitizer (described below). A plastic spoon that holds about an ounce of liquid is a helpful size to have at hand. A thicker coat means, at least in theory, the opportunity for more finely divided etches and, hence, a larger number of color applications.

While the sensitizer is being mixed, mixed with the gum, or brushed onto paper, it is important for you not to perform these operations in direct sun or bright artificial light. Indirect tungsten light or a yellow bug bulb can be used to illuminate the darkroom without affecting the sensitized gum. Unfortunately, the solution spread on white paper is exactly the same shade of yellow as white paper under a bug bulb without the solution. Low tungsten light is probably best.

Making a 10 percent stock mixture of the sensitizer requires an accurate scale. Any chromium compound can be toxic, and reasonable precautions must be taken. Weigh out 0.5 ounce of powdered potassium bichromate (also called dichromate) and mix it thoroughly with 5 ounces of water. If kept in a stoppered bottle and refrigerated, it will last indefinitely. The 10 percent solution of bichromate is a saturated one that will permit no additional bichromate to be added. In fact, the solution will tend to precipitate some particles after standing. It should be stirred well each time a batch of sensitized gum is prepared.

The sensitized gum solution, whether extra thick or regular, should be prepared from about three parts gum to one part of the stock sensitizing solution. These proportions are a compromise, of course. You may wish to work out other proportions depending on light conditions, the degree of hardening desired, and the density of the positive transparency. Because the bichromate is a saturated solution, the sensitivity of the final gum coating can only be increased by adding more of the stock solu-

case, do not add sensitizer directly to this mixture but save it as a thickener.

For an extra thick coating, mix one part thick syrup, two parts of commercial gum at 14 degrees Baumé, and one part stock sensitizer (described below). A plastic spoon that holds about an ounce of liquid is a helpful size to have at hand. A thicker coat means, at least in theory, the opportunity for more finely divided etches and, hence, a larger number of color applications.

While the sensitizer is being mixed, mixed with the gum, or brushed onto paper, it is important for you not to perform these operations in direct sun or bright artificial light. Indirect tungsten light or a yellow bug bulb can be used to illuminate the darkroom without affecting the sensitized gum. Unfortunately, the solution spread on white paper is exactly the same shade of yellow as white paper under a bug bulb without the solution. Low tungsten light is probably best.

Making a 10 percent stock mixture of the sensitizer requires an accurate scale. Any chromium compound can be toxic, and reasonable precautions must be taken. Weigh out 0.5 ounce of powdered potassium bichromate (also called dichromate) and mix it thoroughly with 5 ounces of water. If kept in a stoppered bottle and refrigerated, it will last indefinitely. The 10 percent solution of bichromate is a saturated one that will permit no additional bichromate to be added. In fact, the solution will tend to precipitate some particles after standing. It should be stirred well each time a batch of sensitized gum is prepared.

The sensitized gum solution, whether extra thick or regular, should be prepared from about three parts gum to one part of the stock sensitizing solution. These proportions are a compromise, of course. You may wish to work out other proportions depending on light conditions, the degree of hardening desired, and the density of the positive transparency. Because the bichromate is a saturated solution, the sensitivity of the final gum coating can only be increased by adding more of the stock solu-

tion to the liquid gum. To prevent overthinning, it will be necessary to use the thicker gum mixture prepared from powder, as mentioned above.

The values presented here should be regarded as approximations, neither final nor absolute. Prior to coating the paper, the gum and sensitizer should be thoroughly mixed. It is advisable to prepare only enough sensitized gum to require a few days storage in the refrigerator, but out of reach of innocent hands. A 4-ounce batch, for example, will coat two dozen or more sheets (9-inch × 12-inch image area) of relatively absorbent CP paper and even more than that of HP paper. After a few days of storage, the mixture's sensitivity seems to change and it forms lumps.

Prior to coating the paper, place the precut sheets within easy reach of the counter. Protect the work area with flat strips of newspaper. Spilled gum is extremely difficult to remove once it is dry and hardened by days of light exposure. A clean, reusable, foam brush 2 or $2\frac{1}{2}$ inches wide is ideal for applying the gum. The brush should be slightly dampened with water before you start picking up gum with it. The jar containing the gum should have an opening of about 3 inches, such that the brush can easily be inserted and removed. The purpose of following this rather laborious, detailed procedure is to maximize your chances of coating a piece of paper smoothly and thoroughly.

Lay out each sheet individually for coating, secure it with the thumb and forefinger of one hand, and make fairly rapid, generously laden strokes with the brush over an area somewhat greater than the area to be printed. The slightest flaw (open spot) in coverage will show up later as an unwanted paint mark in the final print.

The skill, acquired with a bit of practice, is to make the coating as smooth as possible, without streaks, ridges, or bubbles. The coating can be checked by briefly turning on an overhead light or moving to a doorway. Missed areas, streaks, and other imperfections can be corrected if done immediately. The

wet and sticky sheet will not drip. Lay it flat or pin it by one corner on a nearby line to dry. Previous books on alternative processes have recommended using a fan or hair dryer to dry the sheets quickly after coating. This is completely unnecessary. It is possible to coat from four to six sheets at one time. As they dry, the sheets must be kept completely separate from each other and from other objects. They dry to the touch in an hour or two. The entire coating process can be performed with rubber or, better, surgical latex gloves to protect your skin from absorbing the chromate.

While the sheets are drying, you should physically leave the area to avoid accidentally touching them or stirring up dust. After the sheets have dried, stack them loosely in a drawer, away from light. They will curl some, but do not attempt to flatten or unbend them as this will disturb the emulsion and is not, in any case, necessary for satisfactory printing. A flat weight of a pound or two can be laid over the stacked sheets. It is probably best to use all the coated sheets within the first or second day after preparation. Long delays sometimes seem to do strange things to sensitized papers. Besides, there are too many variables to keep track of already without adding excessive oxidation.

An alternative to using a layer of extra thick gum, mentioned earlier, consists of coating the paper once, drying it, and coating it a second time. The purpose of this is twofold. First, double coating averages out the varying thickness of the emulsion layer and helps to reduce streaking. Double coating also provides the matrix additional potential depth to be etched away. And therefore, the laying down of a greater number of colors and shadings may become more feasible. Also, a single, thin layer of gum is less forgiving than a thicker layer. More time in the etching bath is necessary when the layer is thicker. Conversely, a single layer can easily be overetched, and this leads to an unattractively stark black-or-white effect without tonal gradation.

Exposure and Development of the Latent Paper Print

THE CONTACT PRINTING FRAME AND LIGHT SOURCES

To produce a latent gumoil print, you must have a device that sandwiches the positive transparency between a sheet of glass and the sensitized paper and holds the sandwich firmly together under a light source for a few minutes. The best commercial contact printing frame is manufactured by The Gravity Works company and is available through suppliers. The printers are presently made in three sizes, the largest of which has usable inside dimensions of 14 inches × 18 inches. Sturdily constructed from hardwood, the front frame with its plastic pane and the hinged backing panel are kept taut by heavy elastic tubes that fasten conveniently into notches. The best feature of all is that these printers come with a sheet of unbreakable $\frac{1}{4}$-inch-thick

53

UVT (ultraviolet-transmissible) plastic. Using glass would have made the devices even heavier than they are and screened out much ultraviolet radiation, making for longer exposure times. UVT plastic permits more rapid exposure times, an important consideration in higher latitudes or on cloudy days. The UVT plastic is a further plus for photographers who also print on hand-coated Vandyke and cyanotype papers, which are even less light-sensitive than bichromated gum.

In a pinch, however, a print can be made without a contact frame by simply placing a sheet of loose glass over the transparency and gummed paper on a firm, flat surface, such as a card table set up outside. Soft focus effects can be produced by separating the glass and transparency a fraction of an inch off the sensitized paper surface. Other focusing effects can be achieved by having the glass sandblasted to various degrees of fogging.

LIGHT SOURCE

The sun is a fine source of ultraviolet radiation, but even desert dwellers have to wait for daytime and clear skies in the absence of a powerful artificial source. Gray climates, latitude, season of the year, time of day, and altitude all have an effect on printing times. A bright, clear day in Albuquerque at a mile high, from 2 hours before noon to 3 hours after during any month, will produce a usable latent gum print in 2 to 4 minutes. These exposure values can vary dramatically, and you will have to experiment. Test strips work fine. A double-coated sheet needs no more exposure than a single-coated one. A "countdown-type" pocket timer with a beeper, one that can be clipped to the outside of a pocket or an apron, works better than a watch. Length of exposure also depends greatly on the positive transparency, with dense ones taking twice or more as long as thin ones. Trial, error, and experience are the guides here. As a printer, you will have to evaluate your own sun exposure conditions and keep a detailed written record to make replication possible.

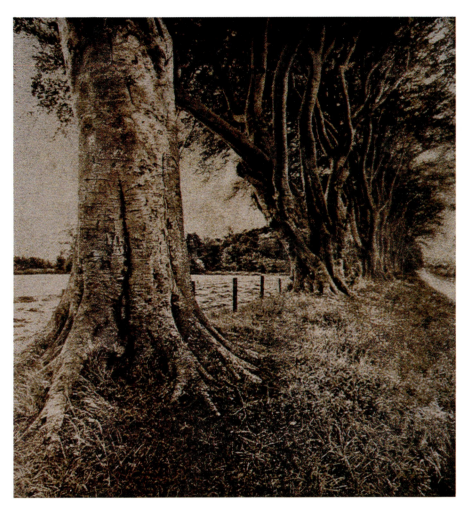

Color Plate 1 *Elie Beeches* (Scotland). Gumoil Polychrome

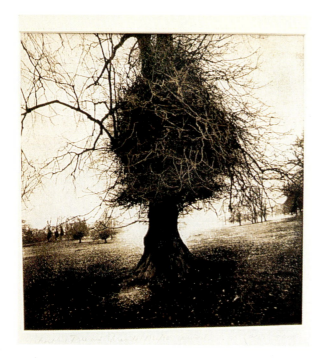

Color Plate 2 *Pitcorthie Tree with Parasite* (Scotland).
Gumoil Polychrome

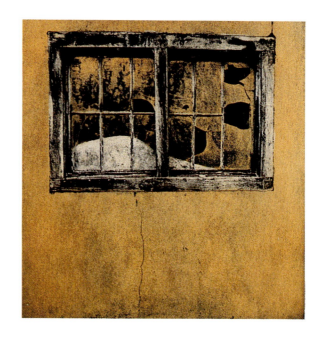

Color Plate 3 *La Cueva Cannery* (New Mexico).
Gumoil Polychrome

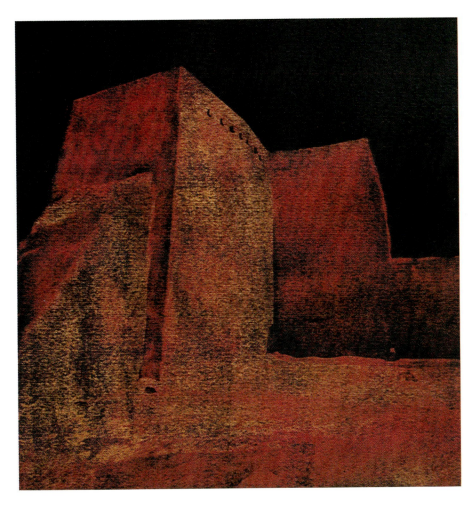

Color Plate 4 *The Church at Ranchos de Taos* (New Mexico). Gumoil
Polychrome

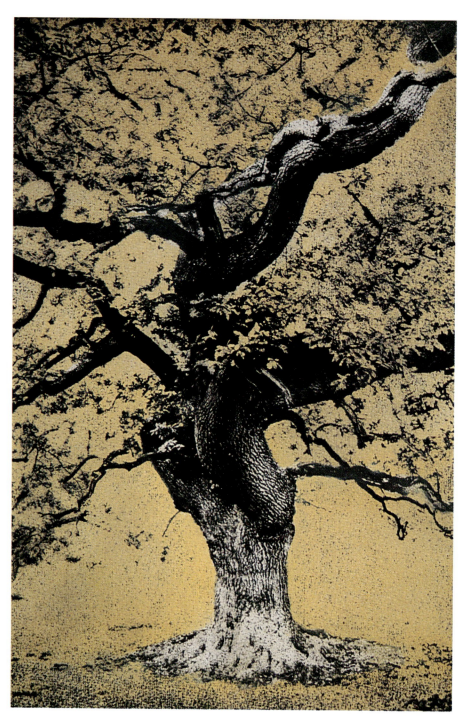

Color Plate 5 *Jervaulx Abbey Tree* (England). Gumoil Polychrome

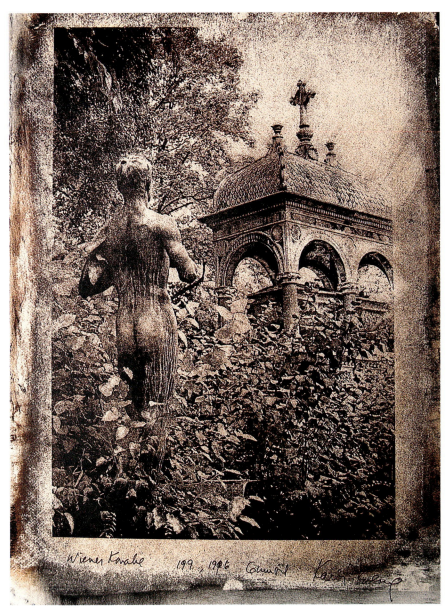

Color Plate 6 *Wiener Knabe* (Vienna). Paper Interpositive

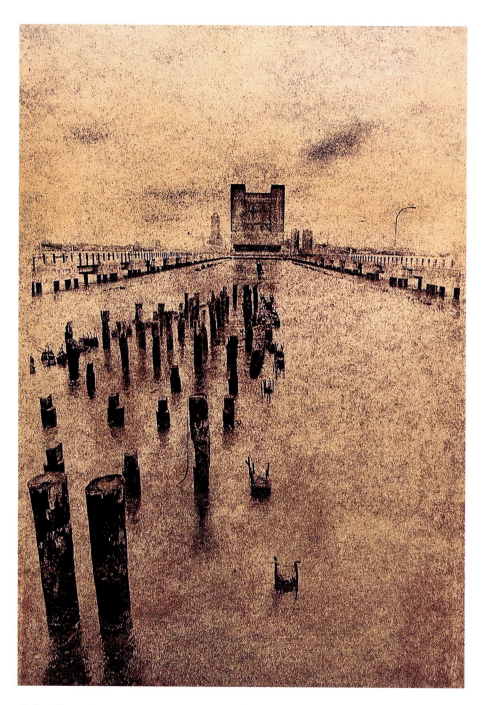

Color Plate 10 *Rotting Piers in New York City* (New York City).
Paper Interpositive

Other light sources include carbon arc and mercury vapor lamp systems such as those found in art labs and printing shops. The advantage of such high technology is consistency. A proper written record would permit reprinting with virtually identical results. These lights are expensive and hard to locate even if you just want to borrow their use. A sunlamp can also be used. Here again, consistency is the advantage because a carefully kept record of times and distance of the bulb from the frame should make a successful latent gum print reproducible. It is also possible to buy or make a light table that employs closely set multiple fluorescent tubes that put out a good deal of UV radiation, though nothing like natural sunlight. The author's experience with one such light table suggests that exposures will be lengthened by a factor of twenty or so. Increasing the proportion of bichromate to total gum may speed up the time, but remember to add some thicker gum if you do. Plans for constructing ultraviolet light tables, at reasonable prices, are available in books by Scopick (1991) and Nadeau (1985, 1987). The Palladio Company sells light tables of different sizes, but for substantially more than it costs to make one or to have one made by an electrician. The problem with the Palladio table is that it doesn't work for gumoil. An Aristo Platinum printer is powerful and may be the best alternative to natural sunlight.

There is a something to be said for relying on the sun, the source of light our predecessors used to such advantage in the last century and early in this one when non–silver nitrate processes were in their heyday. And aside from the fact that sunlight is absolutely free, there is something nostalgic and rewarding about being released from the darkroom for this crucial step in the picture-making sequence.

Assuming the simplest system—that is, the sun together with a Gravity Works UVT contact printing frame—the following procedure should be employed. In subdued light, select a sheet of the coated paper with the coating face up. Hold the positive transparency against the coated side of the paper. In this fashion, be certain that the correct side of the transparency is

oriented left-to-right to print correctly on the final image. Place the positive and the coated paper with it face down on the inside surface of the contact printer's glass. Set the contact printer's hinged back insert into the frame such that it fits cleanly inside and firmly up against the uncoated side of the paper. Fasten it all together with the elastic tubing.

Pick the frame up and look into it just as the sun's light would enter it. The positive transparency should be in front and closest to the glass, and behind it, lined up properly, should be the coated side of the paper. The positive image should fit easily within the coated area. The film must lie firmly against the glass and the paper firmly against the film. Look for gaps because an unintentional separation may put the print out of focus. Furthermore, the back of the frame must fit snugly against the entire package. There is no need to hurry this process, and the whole sandwich may be taken out, readjusted, and repositioned several times before getting it just right. If the film has been punched for registration, it is vital that the paper also be punched with the same setting. Pins, mounted on a strip of acetate, can then be used to register the film and paper together inside the contact printer before exposure to sunlight. Once the frame is taken outside and set down in bright sunlight, it is too late to move the film or paper around.

The frame may be propped on a chair, against a wall, or on a table so long as the positioning permits the sandwich of film and paper to be at right angles to the most direct rays of the sun as they strike the earth. Make sure the light will be unobstructed for the duration of the exposure. When you are using the sun as the light source, you will appreciate how quickly shadows move into your exposure area. Even the wire on a distant utility pole will leave its stripe if it intervenes between the sun and the paper surface.

Once it is firmly in place, the frame should not be moved until it is taken promptly inside and disassembled to extract the paper print and separate it from the positive transparency. It might be noted here that all contact printing frames are con-

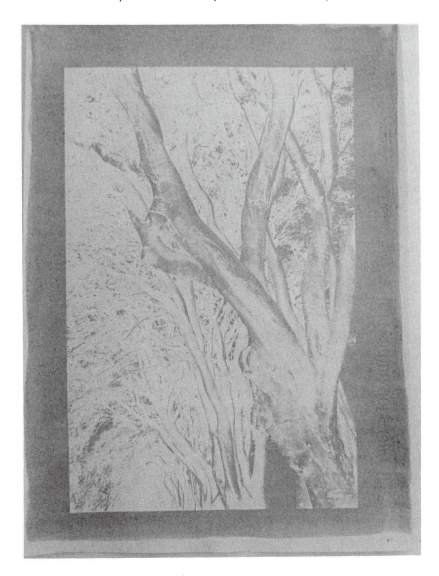

Figure 5.1 A Latent Gum Print before Oiling

structed such that one side of the hinged back can be opened, the paper halfway lifted up, and the emulsion inspected for proper exposure. This sounds far better than it actually works.

What generally happens is that the paper or the film sheet moves slightly as the back is opened, and when the frame is replaced in the sun for additional exposure, a slight double exposure occurs. This ruins the print. It may be better to take whatever chance, or error, has offered and use it in the subsequent oiling processes. Under- and overexposures occasionally result in exciting prints for reasons explained later. Gumoil is a process with considerable latitude, and some of its better results have come from what looked at first like irremediable mistakes. Figure 5.1 illustrates an exposed, developed, but unpigmented print.

WATER DEVELOPMENT

Immediately after exposure, place the exposed paper directly into a large tray filled with water at about 70 degrees and into which a fresh supply of water at the same temperature is gently pouring. This instantly begins the development process, and once the print is in the water, bright overhead lights can be turned on. Good, strong light from this point forward is crucial for making certain the print is properly cleared. The latent gum bichromate print is developed in slowly running water and nothing else. Make sure the print is submerged completely (it will resist you somewhat) and depress it carefully below the surface as it becomes universally wetted. Pick it up gently by an edge and float it face down in the water. It is important not to abrade the gum surface as it becomes progressively softer. Let a gentle stream of tepid water flow into one end of the tray and out the other for 5 minutes or so while the print soaks thoroughly.

Place the print face up again and use a kitchen sink hose-sprayer attachment to cleanse the whole surface. If no sprayer is available, move the print under the (aerated) faucet so that the whole surface gets the benefit of some direct water pressure. The

purpose of this is to float the increasingly loose gum off the paper's surface. It is possible to leave the paper in water for quite a while, and this may be necessary if the gum resists leaving the surface in the places where it should (i.e., the places where shadows and lines should print). The areas of the print that were fully protected from the sun should give up their gum first, and in a short time, those areas will once again be perfectly white.

Wash more rather than less because traces and filmy residues of unwanted gum often don't show up until the print is dry. It will occasionally happen that after a print is left until barely damp, it will become apparent to you that the surface still has slight gum traces in areas where absolutely white paper should be showing. Submerge the print again and wash/spray it some more. If there is trace gum on the area where the print should absorb the first oil color (e.g., black), the paint will be resisted by the gum and a weakened print will result. Specifically, the area will turn out a shade of gray rather than an intense black color. If the print is made on a double-coated sheet, somewhat more washing time is necessary. It is possible to wash too much, also, leaving an over-thin gum layer. Five minutes seems about right, no less.

The brighter and truer the overhead light for inspecting the results of the washing, the more certain one can be that the unwanted, residual gum has been fully removed from the paper. If the positive transparency has good tonality, the exposed and developed gummed surface will exist in three states visible to the unaided eye. The first surface state is characterized by an absence of gum. In these areas, the gum will have been so softened that it has completely dissolved and washed away. These white, fully opened areas will be receptive later to the introduction of oil pigment. The second state, intermediate between the other two, is characterized by a thinner, residual layer of gum that corresponds to intermediate tones or shadows. The third state is characterized by a totally recalcitrant layer of gum

that no amount of soaking will ever remove. Areas representative of each state must be present for a print to be satisfactory as a photographic image with tonality.

Figure 5.1 is a photograph of a latent water-developed print before oil has been applied. The picture, a bit difficult to see, is of the upper limbs of a stand of trees. The characteristic color of the exposed and dried gum is represented in gray in the photograph. Note that the dark and light colors are reversed at this stage; it is, after all, a negative print.

See Figure 5.2 for a schematic representation of how the exposed gum surface is water developed. Note that the gum is gone where the positive was blackest, thinner where the positive was gray, and still thick where the positive was clear. Gross underexposure of a transparency will leave the gum so soft that it will all slide off during water development. Gross overexposure will leave the gum so hard that none of it will come off. In the two extremes, no picture can result when oiling takes place later on. In either of those events, the paper can be dried and saved for recoating on the unused side.

Drying the gum prints requires more care than drying the originally gummed paper. Softened gum at this stage is resting rather unstably on the soaking wet paper. This is probably the fussiest step in gumoil printing, and close adherence to the method is recommended. It is best to drain the freshly (and fully) washed print at a 45-degree angle. This permits positive but gentle drainage. After 5 minutes or more of this, hold the sheet up for inspection. If there appears to be some loose, unsloughed gum, wash it again under a flow and then spray of water for 30 seconds and rerack at a 45-degree angle. This step may need to be repeated. When you are satisfied that loose gum is mostly removed and that the print is not actively dripping, hang it by two corners on a line. Make certain that loose gum is not gradually collecting or pooling anywhere on the print. If it is, wash it, rack it, and hang it again. The print is exceptionally vulnerable to injury at this stage. It will scar, and dirt will easily adhere to it.

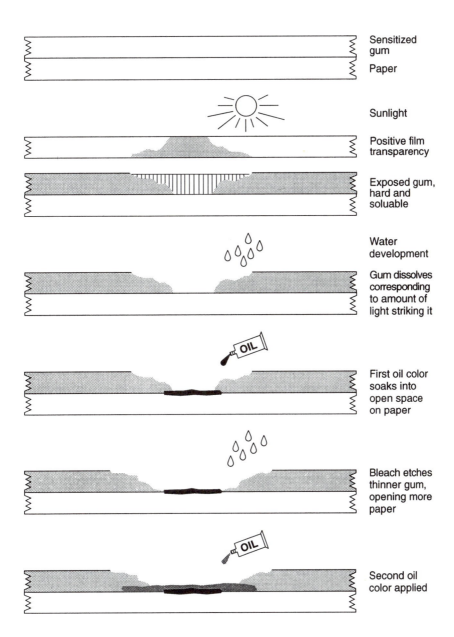

Sensitized gum

Paper

Sunlight

Positive film transparency

Exposed gum, hard and soluable

Water development

Gum dissolves corresponding to amount of light striking it

First oil color soaks into open space on paper

Bleach etches thinner gum, opening more paper

Second oil color applied

Figure 5.2 A Schematic Cross-sectional Drawing of Gumoil Printing

plored. This will only happen when the bleaching and coloring techniques described in Chapter 7 are employed. Once the first application of oil paint is laid down and the excess wiped off, the image comes out strong and clear. The question of tonality is somewhat less crucial if one wishes to print only monochromatically because true tonality is only brought out by the polychromatic method.

See Figures 6.1 through 6.10 for examples of monochromatic gumoils paired with their commercial, gelatin silver–printed siblings. The gumoils were made with Windsor and Newton lampblack oil paint over gum, which was then partially etched away with a bleach solution. This was done not to make way for an additional color, as would be the case if these were intended later on to become polychromes, but rather for the shading and tonality that judicious bleaching and brushing lend. The actual prints are not monochromatic in the strictest sense because in each case, the residue of incompletely removed gum gives the print a touch of color. In the originals, this lends its own subtle but distinctive hue. The reproductions, however, are printed straight, in black and white.

Take a well-dried latent gum print and brush it vigorously with oil paint directly from the tube. If the paint is reasonably fresh, no thinning of any kind is recommended. The purpose at the monochrome stage is to work into the open, ungummed portions of the paper as much pigment as possible. A common, heavy stencil brush works best, although oil paint can be worked into the paper with almost any object, including bits of rag, paper toweling, or even fingers.

Stencil brushes are quite stiff and have a circular configuration of bristles chopped across at a right angle to the iron ferrule. They are available in any good art store in several circumferences. A useful selection will include at least three or four of the sort that have a $\frac{3}{4}$-inch diameter. The advantage of using a stencil brush is that it is a more economical method of applying the paint than rubbing it on with a paper towel or a rag. Oil paint, even student grade, is rather expensive. The stiffness of the

plored. This will only happen when the bleaching and coloring techniques described in Chapter 7 are employed. Once the first application of oil paint is laid down and the excess wiped off, the image comes out strong and clear. The question of tonality is somewhat less crucial if one wishes to print only monochromatically because true tonality is only brought out by the polychromatic method.

See Figures 6.1 through 6.10 for examples of monochromatic gumoils paired with their commercial, gelatin silver–printed siblings. The gumoils were made with Windsor and Newton lampblack oil paint over gum, which was then partially etched away with a bleach solution. This was done not to make way for an additional color, as would be the case if these were intended later on to become polychromes, but rather for the shading and tonality that judicious bleaching and brushing lend. The actual prints are not monochromatic in the strictest sense because in each case, the residue of incompletely removed gum gives the print a touch of color. In the originals, this lends its own subtle but distinctive hue. The reproductions, however, are printed straight, in black and white.

Take a well-dried latent gum print and brush it vigorously with oil paint directly from the tube. If the paint is reasonably fresh, no thinning of any kind is recommended. The purpose at the monochrome stage is to work into the open, ungummed portions of the paper as much pigment as possible. A common, heavy stencil brush works best, although oil paint can be worked into the paper with almost any object, including bits of rag, paper toweling, or even fingers.

Stencil brushes are quite stiff and have a circular configuration of bristles chopped across at a right angle to the iron ferrule. They are available in any good art store in several circumferences. A useful selection will include at least three or four of the sort that have a $\frac{3}{4}$-inch diameter. The advantage of using a stencil brush is that it is a more economical method of applying the paint than rubbing it on with a paper towel or a rag. Oil paint, even student grade, is rather expensive. The stiffness of the

6

Basic Monochromatic Printing

APPLYING THE OIL PAINT

The steps described in the preceding chapters should now have produced a dried, latent print in unpigmented gum on a high-quality sheet of thick watercolor paper (as shown in Figure 5.1). The latent print will be an unappealing khaki color in its high-lights and white in the shadows, and it will look like a negative image of the future print. If the print is going to be satisfactory, it will have visibly thicker areas of residual gum that correspond to future white spaces (pigment-resistant) and some other well-defined areas of white or open spaces (pigment-receptive). In addition, there should be some areas that are more thinly gummed, and these will produce the tonal values required in a good photographic image. See Figure 5.2 for a schematic representation of the various stages of making a gumoil print.

The first coat of oil paint must be laid down long before the print's full promise for depth and tone can be more fully ex-

One reason for draining and drying carefully is that if droplets of excess water-containing gum are formed and inadvertently left to dry on the print, they will later print as light spots on the final oiled print. The washed sheet takes a few hours to dry thoroughly. When it is dry, store in a clean, dark place until it is time for an oiling session. The prints in this latent form seem to last without deleterious effects for a few weeks, perhaps longer.

Coating and exposure dates and notes can be kept in pencil or indelible marker in the margins on the front or the reverse side of the gummed sheets. Marginal notes about time elapsed between procedures, oil colors chosen, and color sequences, bleach baths, and manipulations will prove valuable months later when the history of a particular print eludes the maker. The dried latent gum print is extremely robust and needs no particular care except to avoid creasing or spotting. Although such prints will curl badly, they "keep" for weeks, if not months, before undergoing so much hardening that they become difficult to bleach etch. It is recommended that you use the dried print (i.e., start the printing process) within a few days. The oil in the first paint application helps to keep the gum supple and more susceptible to bleach etching.

Once exposed, the latent print should be water developed within several hours. Waiting a full day or so permits the initial exposure to become intensified, or overexposed. Overexposure results in a print that is less receptive to the oil pigments and a final print that appears weak or underexposed.

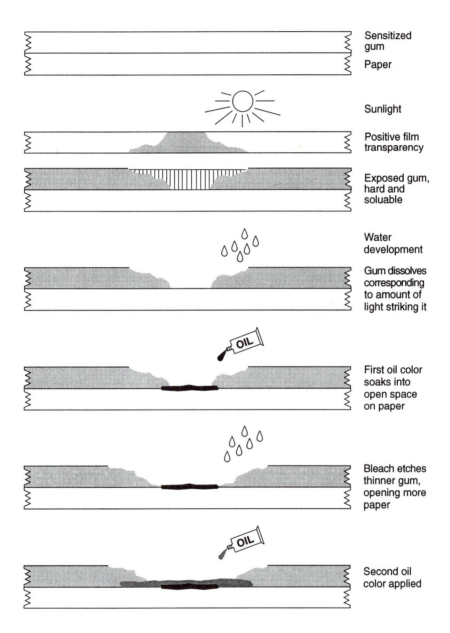

Figure 5.2 A Schematic Cross-sectional Drawing of Gumoil Printing

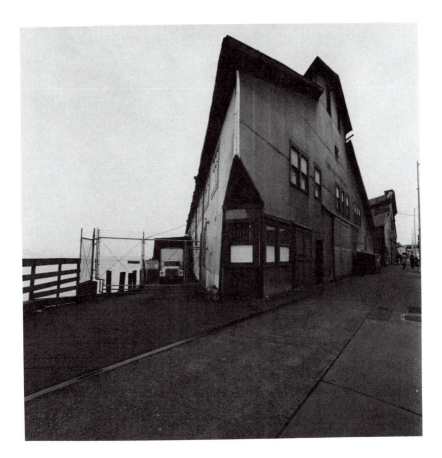

Figure 6.1 *Seattle Pier.* Silver

brush is helpful in working the paint deeply into the paper's fibers. The gummed areas are quite tough and will effectively resist the paint and the pressure. A conventional paintbrush, large or small, would be completely ineffective for working in the oil paint.

Devise a method of organization for your work area. Disposable plastic cups or glass jars to hold the brushes can be lined up against the back of the work area's counter. Each should contain a quarter of an inch or so of linseed oil or some other

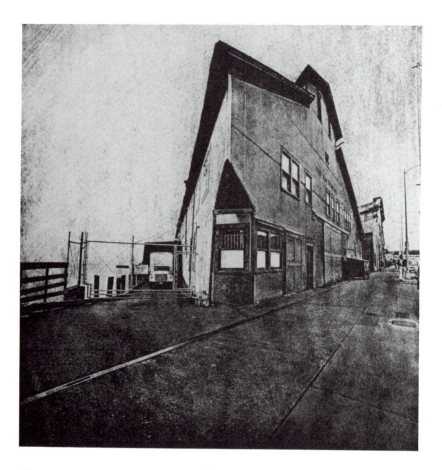

Figure 6.2 *Seattle Pier.* Gumoil Monochrome

vegetable oil (sunflower oil is cheaper and works as well). Each cup corresponds to a different oil-coloring brush. Standing on its bristles in oil will keep the brush lively and flexible during periods of disuse when the only alternative would be to clean the brush thoroughly and put it away. Standing on its bristles will not damage the brush, and it is a time saver because cleaning is a tedious process and one that should be put off for as long as possible. Since lampblack and Payne's gray are used exten-

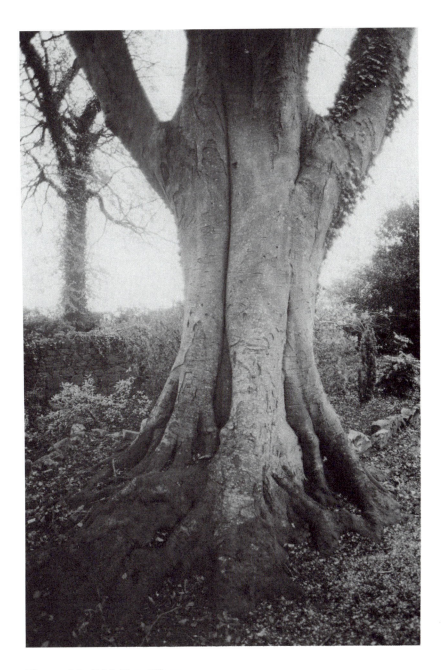

Figure 6.3 *Irish Tree.* Silver

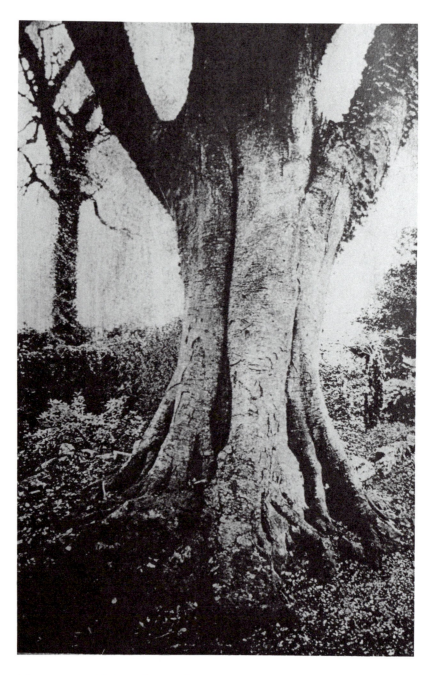

Figure 6.4 *Irish Tree.* Gumoil Monochrome

sively in gumoil printing, and the brushes used for them are easily confused with each other, it makes sense to dedicate two of the cups and two of the brushes to these colors. The number of brushes and cups is obviously a direct function of the number of oil colors that will be used frequently. Label the cups or jars and the brushes with an indelible marker to simplify your job of keeping them matched.

When cleaning the brushes becomes unavoidable, 30 minutes of soaking in Stripeeze brand paint stripper works best. It is very potent and will tend to loosen the bristles if allowed to impregnate the ferrule. Do not use plastic cups for cleaning because paint stripper dissolves them. In a glass jar, filled to two-thirds of the height of the bristles as they stand upright on the bottom, soak the dirty brushes and then work the pigments out on newsprint or rough-cut wood boards until the brushes are moderately clean. Do this outdoors if possible. The warmer the ambient temperature, the better and faster the stripper will work. A strong solution of detergent and water will then help to remove the remaining oil color from the brushes, although they do not have to be completely clean. The brushes then should be allowed to dry. Occasionally, one must clear and clean the whole group, especially if the brushes have sat in oil for several weeks without being used.

A brush should never be used for paint application directly from the oil bath. Extra oil may be squeezed off and the brush then worked on some toweling to make certain it is not carrying a load of oil. Any excess oil will tend to thin the paint being laid down and weaken the image.

COLOR SELECTION

Among oil paints, there is a virtually infinite selection of brands and colors. This can be appreciated by visiting a first-rate art supply store or reading through a comprehensive catalog. Keeping the number of variables small in gumoil printing is the first

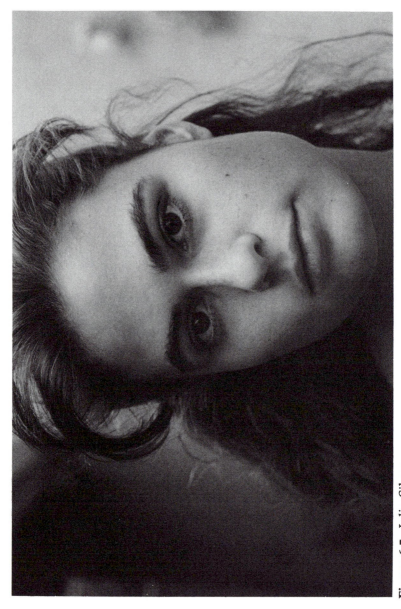

Figure 6.5 *Julia.* Silver

Figure 6.6 *Julia.* Gumoil Monochrome

step toward getting good, reproducible results. In your initiation to the method, it is useful to keep the paint brand the same and the number of colors extremely limited.

On balance, the most satisfactory brand of paint to date seems to be Windsor and Newton's Winton, which is excellent from several standpoints. It is reasonably priced, it has a moderately heavy intensity, and its consistency is such that it covers well. The pigments (usually) saturate or color intensely, they are widely available, and they come in 37-milliliter and 200-milliliter tubes. Since this chapter is limited to monochromatic printing, no particular consideration will be given to choosing pigments for blending with a second or third pigment. In monochromatic printing, it is best to use strong, dark pigments, such as lampblack or the other blacks, Prussian blue, burnt umber, and Vandyke. Colors may be mixed to achieve a hue that most enhances the image. Lighter colors may also be used if you expect the print to remain a monochrome. If you intend to carry it further (see Chapter 7), a lighter color will probably not be satisfactory as subsequent colors tend to obliterate the first color if it is not very powerful.

Squeeze a generous worm of oil color onto the middle of the image and work it into the paper gradually and thoroughly with the stencil brush. Thinning the paint is to be avoided unless the condition of the paint makes it absolutely necessary. Brush and spread the color to the four edges, taking care that the entire image is fully but not copiously covered. No paper surface should show at all except the margins when you have finished brushing. Excessive paint on the surface is merely wasted paint at this stage. The print can then be set aside to allow the pigment to sink well into the paper's fibers.

After 20 minutes or so (but don't wait much longer), the paper held at an angle to the light will usually show a faint image caused by the differential absorption of pigment, and this is an indication to you that it is time to begin the wiping-off work. Paint left too long on the paper at this stage can become extremely difficult to remove. A few sheets of good-quality

Figure 6.7 *Tipperary.* Silver

Figure 6.8 *Tipperary.* Gumoil Monochrome

Figure 6.9 *Jenny* (Scotland). Silver

paper toweling can be used to start the process of cleaning off the excess oil. Finish the job with cotton rags or terry cloth scraps. Small gym or shop towels work very well. These are more effective than paper toweling for the final clearing and polishing. The clearing process requires a fair amount of physical work and some experience in order to get it right. If the paint is sticky rather than buttery, it will resist the removal process.

Perseverance will be rewarded by a gradually emerging image that becomes clearer as the rubbing continues. You are in

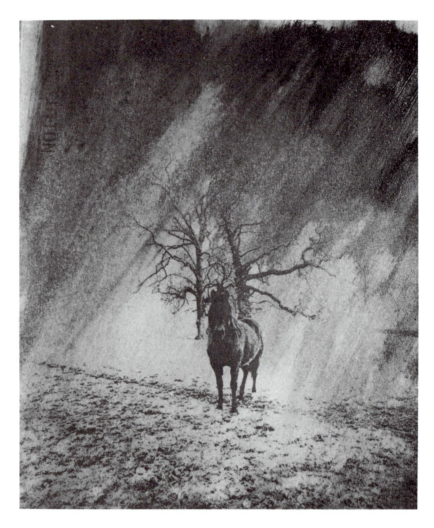

Figure 6.10 *Jenny* (Scotland). Gumoil Monochrome

little danger of erasing the picture. On the other hand, do not add oil to facilitate the task because oil will have the effect of lifting the pigment directly out of the paper, leaving too pale an image. A touch of vegetable oil on the towel, in stubborn cases,

may be necessary to clear the image. The picture may be considered finished at this point.

Selective lightening or darkening is possible for another day or two, and a drop of oil at this advanced stage, and after some study, may be useful in gently rubbing some of the color out. Similarly, fresh oil paint of the same color can be rubbed into any region of the print and then wiped clear. You may now want to remove some of the gum even though you intend the print to be a monochrome. As mentioned above, light bleach etching adds tonality to the print, and it does this by removing gum in the thinner spots and brightening the highlights. The image tends to be, overall, rather dark if this step is omitted.

Other possibilities can now be explored. You may decide to add, after one or two days, a second and different color to modify the first. For example, if the first (lampblack pigment) is too somber, it can be made lighter and bluer by overpainting with Payne's gray or Prussian blue. The second pigment is brushed onto the print and then cleared off with toweling after waiting 20 minutes or so. The modified lampblack will lighten and take on some tones of the second color. Likewise, a weak initial color can sometimes be strengthened by overbrushing with a darker one and later toweling it off. A black printed picture can be warmed by overpainting with one of the brown hues.

After either simple drying or additional coloring, the picture may be satisfactory just as it is. If the color of the residual gum is not pleasing, there are three chemical methods to remove the gum's olive-yellow color that remains in the white spaces. A 5 percent alum bath, a 5 percent metabisulfite bath, or a 5 percent sodium bisulfite bath will each do the job. They do not remove the gum, only the coloring in the gum. Attempting to pull the residual gum out with strong bleach can work, but it makes the prints look dead.

When the oil paint is reasonably dry, after about two weeks in a warm room, the picture can be brush or spray varnished to

produce a matte or glossy surface. Varnish helps to bring up the intensity of the color and details, but tastes vary on the matter. The same effect, in a somewhat more subtle fashion, can be produced by lightly applying a thin coat of linseed oil, but the oil paint must be completely dry or the linseed oil may tend to lighten the color.

It is useful to get into the habit of recording your printing notes on the back or margins of the picture. Date, time, and length of exposure, other conditions, type of gum, development techniques, pigmenting, and other treatments are important data for learning and replication.

7

Polychromatic Gumoil Printing

Chapters 7 and 8 provide details of the final steps in the sequence of techniques that make gumoil a unique photographic printing process.

Now that you have mastered monochromatic printing, you can reasonably attack the polychrome process and its oddities, obstacles, and joys. The ability to print well in monochrome guarantees that you have sufficient competence in negative image selection, positive transparency enlargement and printing, gum and paper preparation, pigment oiling, and finishing to move on to the next step. When you have followed the sequence and produced several good monochromatic prints, set them aside for file reference, framing, or to be processed further in the next step: polychromatic gumoil.

It is gumoil's capacity for rendering polychromatic prints that makes the process most special. This takes nothing away from gumoil monochromes, which can be very satisfying for

particular images. Because gumoil makes it possible to use any (single) hue in the monochrome, some printers may choose to stay at this level.

Still, polychromatic gumoil prints, even in their most understated and conservative form, are exciting in some ways that monochromes can never be. Polychromatic gumoil produces a total gestalt derived from its several component features. One such feature is the oil-based colors themselves, whether it be colors in a tightly controlled range or colors in a bold panorama of disparate hues. Pure oil pigments are deeply intense, and that fact differentiates them from the more traditional methods of bringing color into photography such as through modern silver-based color printing, selective hand coloring, or the use of water-soluble colors in traditional gum bichromate printing. Another contributing feature is the surface texture, which can only be fully appreciated by examining original prints. The texture consists in part of the paper's own weave, the differential layering of built-up oil pigments in the foreground, and the unusual background of residual oil paints and undissolved gum. This is especially true in white or light gray backgrounds because what the process necessarily leaves behind in residue colors on the sheet is visible. The pictures have something of the look of lithography, yet they are also reminiscent of intaglio printing. In fact, the polychromatic gumoil print looks like nothing else in photography, but it is a true photograph.[1]

TWO-COLOR PRINTING AND ETCHING

If you have a good monochromatic print in front of you, one that consists of a single oil pigment embedded in the matrix of open spaces in the gummed surface, you have the basic prerequisite for making a polychrome. The positive transparency used to make the monochrome will have been one with good tonal values. It is these values in the positive that serve to make the gum layer differentially thinner in the middle ranges, and it is

these portions that will etch more quickly than the thicker layers. Only when some of the gummed area is etched can the underlying paper accept the second color. The best first color (for the monochrome stage, that is) seems to be lampblack, perhaps because it penetrates the paper most thoroughly or perhaps because it is especially dense and neutral. For whatever reasons, it seems to work best. Some of the black pigment inevitably sinks into and under the gummed areas, especially where the gum is thin and is more porous or cracked. This produces some tonality, even at the monochrome stage, and it adds interest, unpredictably to be sure, to the final polychromatic print. Among other features, it is this semipermeability of the hardened gum coat at each pigmenting stage that makes a gumoil print unique.

Polychromes from the simplest to the most complex were chosen to illustrate the range of possibilities in gumoil. These are shown in Color Plates 1–5 and on both covers. For comparison, the corresponding pictures in black and white on gelatin silver paper are shown in Figures 2.1 and 7.1–7.6.

As a printer, you must choose from a simple, yet infinite, palette at the two-color stage. If the first color is lampblack, the only remaining option is the second color, but it can be any color. The choice can be relatively subtle—for example, Payne's gray or burnt umber out of the tube or some mixture of colors with perhaps the addition of a little black to make the bridge between the monochrome's black and the second color more gentle. Color Plate 1, *Elie Beeches*, was printed in lampblack first and a mixture of brown and yellow ochre second. The image is a satisfactory one in simple black and white as a conventional silver print in Figure 2.1. It seems to be far more effective when some of the shadow areas are rendered in a second color, and in another printing (not reproduced here), Payne's gray was also successful as the second color. Brilliant greens, oranges, and reds are probably not right for this picture. The use of extremely bright or unnatural colors for landscape scenes tends to produce a poster or silk-screen print effect. Notice that the picture illus-

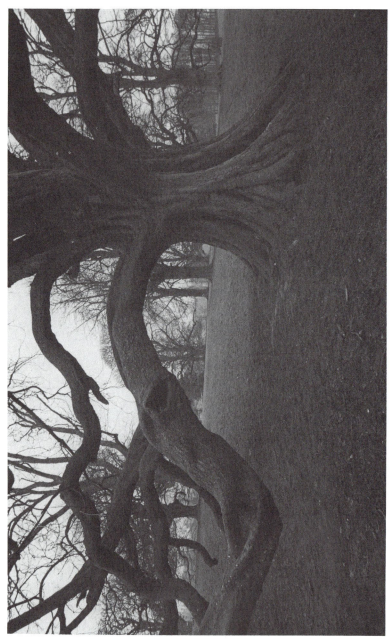

Figure 7.1 *Blenheim Palace Oak (England).* Silver

trated has definite blacks, but they appear to be slightly under-printed (as a result of originally overexposing the latent gum image). When the monochrome stage is too heavily printed, the subsequent polychrome will sometimes suffer for lack of enough "room" for the next color or colors.

The gumoil process does not simply add one layer of color next to another. The bleaching and manipulation described below work to slightly weaken the first image as well as open up further gummed (intermediate shadow) areas for the second color. Therefore, the second color affects the first by adding to it, and the first color affects the second—all the more so if the first color is not absolutely dry at the time the second is applied. A blending occurs that is not always successful. The printer strives to control an interactive but precarious balance between first and second colors. Because the balance is difficult to achieve, a fairly high rate of failures and near hits is inevitable. You will probably discard (eventually) many more gumoil prints than you keep.

Gumoil printing in polychrome requires more time than monochrome, usually encompassing a period of three weeks (often even longer) to produce a finished and fairly well dried print. If the print is going to fail, however, it usually becomes apparent during the first bleach etch bath or even earlier. In polychromatic printing, the increasing number of process variables makes outcome predictions speculative for any particular image, and it is absurdly easy to ruin a print even after a first and second color have been successfully laid down. The gumoil process is still in its early experimental stages. Few facts about the process can be stated with certainty, and those who work with it for the next few years will be true pioneers.

To summarize, a two-color print begins as a monochrome. It can be a print that has been stored for two or three weeks (much longer becomes problematic), or it may have been recently made, as long as most of the excess surface oil paint has been rubbed off and a tissue rubbed on the surface, prior to the second color application, picks up only a small amount of pig-

ment. It must not be varnished or fixed in any way at this stage. Although it is possible to perform the etching bleach bath immediately following the first oiling (and wiping off), it often seems to be slightly better for oil color stability to wait about one hour before etching.

The ideal timing consists of oiling a series of prints as described in Chapter 6 to produce black monochromes late on the evening of the first day. These are left spread out in a dry, clean setting. Early the next day, a fresh bleach bath is prepared for etching, and that sequence is described next.

The etching bath is made from 1 part household bleach[2] to 4 parts or so of tepid water. The more water proportionally used, the slower the etching but the greater the control, and vice versa. Prepare the bath in a tray that can be permanently dedicated to the process because as gum comes off in the bleach, so also does some of the oil paint that once sat on top of it. The result is a virtually permanent oil color staining of the tray. (Although one forfeits the tray for other purposes, one also need not really worry about cleaning it again either.)

Submerge the print in the bath and count out the seconds, while gently sloshing the tray (and therefore the print) by tipping it front to back, back and forth. Observe the print carefully for slight changes in the gummed shadow portions. These areas will generally be those adjacent to the already blackened parts. Remove the print after a count of 10 to 15 seconds, or sooner if changes in tonal areas of the gum *appear* to be occurring. A slight lightening or graying of the gum is an indicator. One can always bleach more later for various lengths of time, if necessary. But once the gum has been etched, there is no satisfactory way of reversing the process short of total drying, regumming, and reexposure at a much later date. And even then, it's not likely to work well.

Unless you wear protective gloves, the bleach will soon crack your skin, especially at the vulnerable joints, the cuticle, and wherever the skin is already sensitive. These cracks are painful and very resistant to healing. A large box of disposable

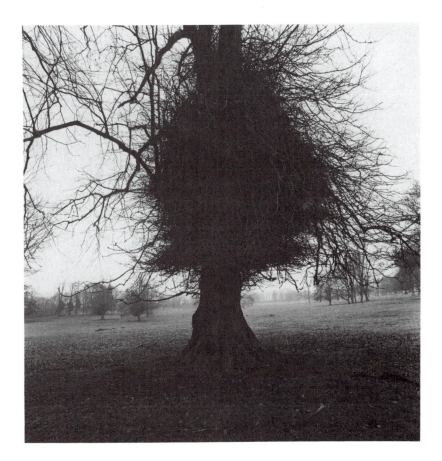

Figure 7.2 *Pitcorthie Tree with Parasite* (Scotland). Silver

latex surgical gloves is the best solution for your health and comfort. They need to be either-handed, thin enough to permit good sensitivity, and lightly coated with talc inside. These gloves wear out quickly and should be discarded at the first sign of a leak, and they probably should be worn during all processes, not just the etching bleach.

Submerge the print promptly in an adjacent second tray, with lightly running tepid water. This tray, too, will become filthy as pigment and gum wash away, and it should also be

Figure 7.3 *La Cueva Cannery* (New Mexico). Silver

dedicated to the gumoil process. The running water, initially, should not fall directly on the print. If the print has been bleached a little too long, it will be vulnerable, and the pressure of falling water may remove more material than desired. As the print is gently sloshed back and forth, you should study it for signs of gum loosening. The sink sprayer, a really important tool in the process, can be directed around the print while checking it for ongoing erosion in the shadow edges. There are

no comprehensive directions that can be given at this stage. The only absolute truth is that *some* gum must come away in order to achieve a two-color effect later on. How much should come away is an artistic judgment, but the process is difficult to control.

One can see quite dramatically at this stage whether either the original negative or the enlarged positive transparency was too contrasty. If it was, then no satisfactory tonal areas will be printable. Even when there is a decent tonal range in the transparency, the picture may still be one that is very difficult to print without several remakes of new exposures on gummed paper. Although the gumoil process is only for images with good halftones, there are other variables that can interfere seriously. The most important acquired skill involves estimating the amount of gum to be etched away and learning how to control it. Experience with the process and a projected understanding (a previsualization, if you will) of what you want in the final image will lead to increasing confidence with the etching phase.

After you inspect the print, it may need to be placed back in the bleaching bath for some additional etching. But again, the seconds should be counted out and the print observed closely for changes. A rough rule of thumb is a count of 10 to 15 seconds for the first bath, with counts of 5 to 10 seconds for the subsequent (corrective) ones. The reason for subsequent baths is that bleach etching, for whatever reasons, takes longer in some cases than in others, and the first bath is sometimes inadequate for removing the desired amount of gum. The double gum coating method mentioned in Chapter 4 may, for example, require considerably more bleach etching time than single-coated paper.

If too much gum is removed, the print loses the capacity to preserve uncolored highlights showing through the second color, and an unsatisfactory print will result. In such a case, the addition of a second color (e.g., Payne's gray) will do nothing to keep the print from being flat and uninteresting. A black print together with a second color of gray but with no highlights will simply look like a single-tone black print made on gray paper.

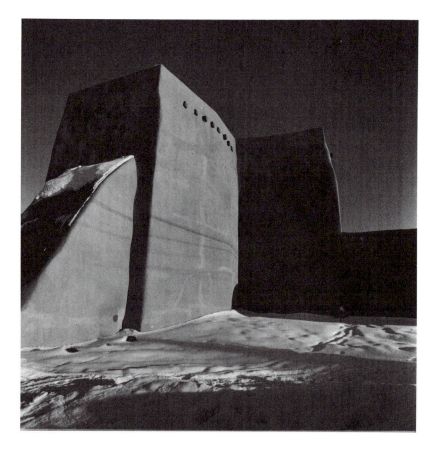

Figure 7.4 *The Church at Ranchos de Taos* (New Mexico). Silver

However, if by chance the monochrome was made in pin regis-
tration with its positive transparency, it may be still be possible
to perform one of the overprinting manipulations discussed in
Chapter 8 and rescue the print. Spoiled prints should always be
saved, at least for a time, because redemption is sometimes
possible.

When the original lampblack monochrome print (later to
become Color Plate 1) was bleached, enough gum was removed
to allow for the second color to move in when it was oiled about

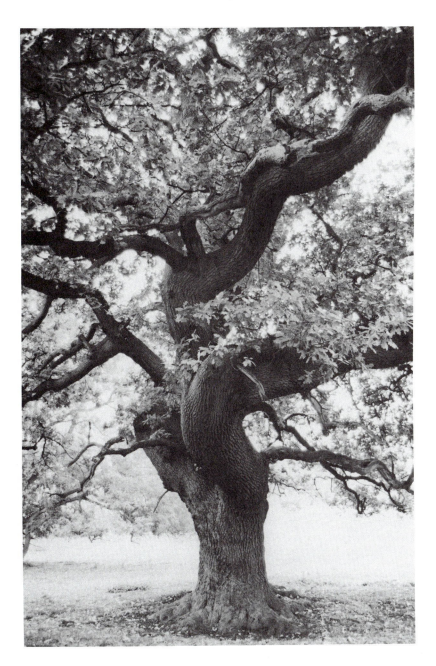

Figure 7.5 *Jervaulx Abbey Tree* (England). Silver

three days later with ochre mixed with brown. When it was bleached gently a *second* time, the last of the gum was removed, leaving white highlights. The softness and blending of the second color with the first, and with the white spaces, was achieved while the print was still wet from washing following the second bleaching. A soft artist's sable brush was used to stroke the white space surfaces and achieve two things: the first was to clear away and/or smooth out residual gum and oil; the second was to move the second color around some, both out of and into the white spaces, but also to blend it slightly with the lampblack.

This was done while the print was dripping wet and supported at a 45-degree angle. In addition to the brushing, cotton Q-tips and bits of dampened paper towels were also used to dab at portions of the picture while it was draining. The purpose was to lighten the print by removing excess gum and color. The paper was cold-pressed Fabriano Artistico, which has a significant tooth. The tooth holds oil color, but not so stubbornly that much of it can't be removed while the paper is still wet.

During this stage, the print is extremely vulnerable. Brushing another print accidentally against it will leave a permanent streak. Touching it with a finger will smear it. Drops forming on the surface, if they are not delicately removed, will result in unattractive spots. After thorough drying, an appropriate finish can be chosen if the printer decides not to proceed to add a third color. In the present example, however, no finish was used, and the picture has a soft, clothlike matte surface.

The preceding may convince novice gumoilists that the process demands at least as much work as is required to make fine gelatin silver prints or platinotypes. Even though gumoil probably provides more ways to ruin a print than any other process, it also provides more ways to make an image ultimately work. In any case, it requires as much work as any other method.

The potential variations in making a basic two-color print are enormous when one contemplates a palette with infinite combinations and permutations of color and concentration. Color, of course, is not the only significant variable available to

the gumoil printer. Apart from the original negative's quality and composition, there are numberless varieties of positive transparencies that can be generated from it. To these can be added the variations in gum viscosity, concentrations of the sensitizing solution, length and type of exposure to sunlight (or some other light source), choice of papers and textures, length and strength of bleach etching, brushing manipulations, and the extent of the oil paint's dryness before another color layer is added. Nor is all oil paint the same, and some paints are more densely pigmented than others.

It should therefore come as no surprise that every gumoil print can be considered a virtual monotype—each a unique configuration of color, paper, and residual gum—no matter how conscientious the printer is in attempting precise duplication. With great care and concentration, however, it is sometimes possible to produce a suite of approximately identical prints.

THREE-COLOR PRINTING

Laying down three or more colors is, in principle and in practice, no different than laying down two. The application of three colors simply means that a bleach etch bath is used between each of three colors, and usually, a final etching bath and wash are used after the last color to bring out remaining highlights. Fairly vigorous brushing of the print after the third color layer soaks in the etch or the wash may be required to free up the last of the gum traces.

There is no theoretical limit on the number of color layers that can be applied. At this point in the evolution of gumoil, however, there seems to be a practical limit of four or, on occasion, five. The process is absolutely limited by the amount of residual gum one manages to retain on the paper after each bleach etching bath. It may turn out that techniques or chemicals will be discovered to stretch out the capacity of the gum to leave ever more finely graduated traces of itself on the paper.

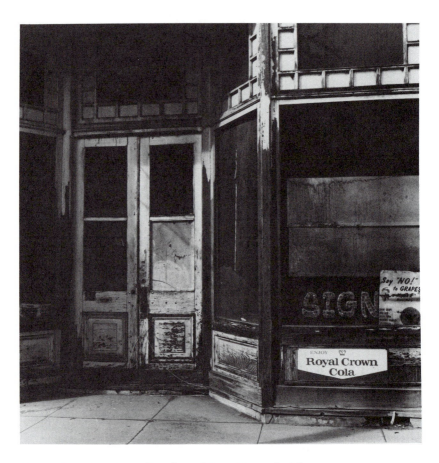

Figure 7.6 *Las Vegas Storefront* (New Mexico). Silver

Besides Color Plate 1 and the back cover, which were made from two colors, the other color plates here are reproduced from prints made with three or more colors. Color Plate 2 is a three-color print in which considerable final etching, washing, and brushing were necessary to bring out the lighter sky portions. The third color, a mixture of Payne's gray and chrome yellow, was difficult to remove because the underlying gum layer had become too thin to protect against absorption by the paper.

Attempts to duplicate this version have been marginally successful. The remaining polychromatic prints were manipulated by methods described in Chapter 8.

NOTES

1. A true photographic image is one that is characterized by continuous tone and no discernible grain pattern. Examples include salted paper prints, cyanotypes, platinotypes, albumen prints, collodion prints, and regular gelatin silver prints. This is in contrast to photomechanical processes, which always have a patterned (rather than a truly continuous) image grain and which, of course, have great replicability. Examples of the photomechanical processes include Woodburytype, letterpress halftone, photogravure, and the collotype (Reilly 1986). Many beautiful fine art prints were made by the photogravure process, and they are extremely valuable today. Indeed, people have begun to use photogravure presses again for fine art work.
2. The author uses unscented (!) Clorox. Generic brands may be fine, but they have not been tested.

8

Variations and Manipulations

The gumoil process can be used as a "straight" printing method by staying within the parameters discussed in Chapters 2–7. It also has an extensive potential for manipulation, and some of these techniques are discussed in this chapter. As is the case in traditional, gelatin silver photographic printmaking, gumoil prints can also be manipulated in three basic ways. First, alterations can be made as the picture emerges in the printing process, during the coloring, or in subsequent bleaching, brushing, and dabbings while it is still wet, as described in Chapter 7. Second, alterations can be made after the picture has been printed or partially printed—that is, by overprinting a first image, using a combination of more than one method. And third, alterations can be made by intervening much earlier at one of the film stages, either by manipulating the original negative or by manipulating the enlarged positive transparency in the special case

of gumoil (or the enlarged negative in the case of the other printing methods).

Many of the techniques for image manipulation now used routinely in contemporary photographic practices (Hirsch 1991; Stone 1979) can be applied in gumoil either to the enlarged positive transparency or to the enlarged internegative. For example, Sabattier or solarization effects can be applied to the enlarged positive, with the effect then being transferred directly to the final gumoil image. Multi-image sandwiching also works well in gumoil. Masking or other hand-drawn manipulations can be applied directly to the large positive. Clear polyethylene sheets, to be positioned between the film positive and the sensitized paper, can be directly marked on with opaque inks, masking material, crayons, or reticulated tusche washes. This saves the large positive for straight printing.

The print of *The Church at Ranchos de Taos* (shown in Color Plate 4 and as an unmanipulated silver print in Figure 7.4) is an example of how masking can be directly applied to the enlarged positive film (without touching the original negative). The sky in the enlarged transparency was completely and carefully filled in by brushing with liquid masking ink. Any ink that adheres without beading works for this purpose. Darkening the sky like this converts a daytime picture into an apparent nighttime picture. This picture was also chosen to demonstrate that gumoil can be worked to create surreal effects through color choice. The image is unusual because no white highlights at all were preserved.

A fully cured but unvarnished gumoil picture is sometimes suitable for overprinting with a fresh layer of sensitized gum, which is reexposed through the same transparency in registration, redeveloped, and then reoiled. Getting the gum to adhere to the surface of the print may require repeated brushing because the oil-painted parts of the picture will tend to reject the gum. The objective is to make sure you get the new gum to stick on the white or relatively uncolored spaces. Doing this, followed by reoiling, serves to reinforce and dramatize the central image.

Overprinting techniques may also be used for superimposing completely new contrasting or complementary images.

Water-soluble photographic chemistry such as Liquid Light, Vandyke, or cyan may also be used in combination with gumoil to supply new detail or definition in the nonoily white spaces. In general, however, the gum and oil paint layers must be established first when they are to be combined with other photographic processes because the powerful bleaching steps associated with gumoil will destroy previously laid down images in any other medium (Koenig 1992).

The gumoil process may be used to print on paper, wood, fabrics, unglazed clay panels, and other surfaces that are sufficiently absorbent to hold the sensitized gum and the subsequent oil color applications. Although it is possible to print on diverse materials, the most successful surface remains the heavy, 100 percent cotton rag, watercolor paper discussed in Chapter 4.

AREA COLORING

One purpose of adding to the color effects already available in the gumoil process is to enhance a print's quality of realism; that is, to make the image look more like those one expects to see in conventional color photography and painting. In this sense, selective coloring can gently nudge a gumoil picture toward realism. This is achieved at the risk of being either so successful that one might as well have used an ordinary color film and paper process in the first place or so ambitiously realistic that the result becomes a paint-by-numbers photo-realism exercise.

Some of the best results come from a "regional" coloring approach. For example, one large portion of a picture might be covered with vegetation whereas the rest is not. The picture is printed first in lampblack and, after bleach etching, colored with burnt umber. While that color is being worked in, a third color, such as sap green, may simultaneously or soon afterward be brushed into (and wiped off) the vegetated area of the picture.

When this works well, a suggestion of greenness turns up in the predominantly brown-black picture. It is not obvious and may not even be consciously seen by viewers unless they are shown a print without the added green. The technique works best when demarcations between the to-be-manipulated and straight printed areas are relatively gradual and diffuse. No examples are reprinted here.

A brush or cotton swab is helpful if the area to receive additional color is small. Your fingers, a small stencil brush, or toweling can be used to apply color in larger spaces. After the oil has been pushed in and allowed to set for a few minutes, the excess is rubbed off with bits of toweling. If the area to receive color is a highlight (white space), it is often preferable to spray the entire picture surface first with an aerosol varnish such as Liquitex Soluvar Matte. This seals up the darker (oiled) portions, but the highlights tend to remain sufficiently open and will accept some new color. No bleach etching should be attempted after varnishing the paper.

SELECTIVE COLORING
THROUGH MASKING

Masking, whether by means of ordinary painter's masking tape or fluid latex brushed directly on the print surface, produces a relatively sharp demarcation between the colors in one portion of the picture and another. Masking can accomplish this without smearing or bleeding across colors. The picture on the front cover, *Blenheim Palace Oak,* and Color Plates 3 and 5 are examples of how a latex mask or frisket can help to establish figure and ground more emphatically than printing by straight gumoil. Liquid latex provides the printer great latitude in selective coloring or protection from coloring. Unlike gum arabic, it is not repelled by the oil surface. It is important to use generous amounts so that a single, relatively cohesive layer is formed to

facilitate later removal. When you use a brush to apply the liquid latex, it is critical that you first soak the bristles in a few drops of dishwashing detergent dissolved in an ounce or so of water. This keeps the brush from seizing up as the latex begins to dry. This measure guarantees long life for the brush and easy washing out.

The *Blenheim Palace Oak* cover photograph was taken with a Canon F-1 camera with a Canon 20-millimeter lens on Kodak's T-Max 400 35-millimeter black-and-white film. The gumoil print was first pigmented in lampblack and etched in a bleach bath, then put aside to dry for two or three days. Etching permitted filling in the next-opened-up (i.e., thinner) gummed areas, and the picture was then covered with burnt umber oil paint. After excess oil was cleared away, the print was etched and allowed to dry for another three days or so.

Next, the limbs and trunk of the tree were carefully and thoroughly covered with liquid latex to protect them against the third color. The latex dried for about 10 hours, and the third oil color was brushed in. In this instance, Payne's gray and yellow ochre were mixed to produce an olive-green hue. The latex was peeled away to reveal the underlying tree and limbs, untouched by the third color, which had saturated everywhere else. With a soft cloth, it was possible to blend a bit of the fresh olive color lightly and judiciously back into the tree. Without this step, the tree and its branches might have looked artificially superimposed over the background instead of becoming part of an integrated scene. The picture was glossed with aerosol varnish after drying for about four days. Several weeks were required for complete curing of the print, longer than usual, probably because the varnish was applied too soon.

La Cueva Cannery (Color Plate 3 and its silver counterpart in Figure 7.3) was a challenging picture to mask. The liquid latex had to be applied with a tiny brush as precisely as possible to the window's woodwork. The photograph was taken with a 6 × 6 Kowa and an 80-millimeter Kowa lens, using Kodak's Tri-X film.

The gumoil print was made in lampblack first and Payne's gray second, with bleach etches following both applications of oil paint. This produced a splendid duotone print with a lot of white, or mostly white, space, which seemed to beg for some additional color. When the first two colors had dried for three or four days each, liquid latex was applied to the window sashes and moldings and to the mysterious shape behind the windows. Windsor and Newton's Gold Ochre oil paint was worked in carefully and then wiped clear without disturbing the thin lines of masking material on the window sashes. Q-tips and small bits of tissue wrapped around toothpicks can be useful for clearing paint near fragile strands of latex. After some drying time went by, the latex was stripped off. Removal of the strands took considerable effort because the latex had been allowed to dry too long. You can use a toothpick or straight pin to access a tenacious strand and start the removal process without damaging the underlying image.

It is probably best not to wait more than twelve hours to begin the latex removal process because waiting longer seems to invite greater adhesion and this, in turn, means that the removal of latex will also lift off some of the underlying oil pigment. This is usually not desirable. The cannery print was softly wiped with cloth or tissues after the latex was stripped away to help blend the picture's different components.

The picture, titled *Jervaulx Abbey Tree* (Color Plate 5 and Figure 7.5 in silver), is of another English oak. It was made in 35-millimeter format with a 20-millimeter Canon lens. The film, in this case, was Ilford 400 ASA. The first image was printed in lampblack oil paint and etched. A few days later, it was ready for coating with Payne's gray and another etching with the bleach solution. After this stage, it was necessary to permit four or five days to pass in order to allow the gray oil to set up enough in the paper so it would be able to resist being pulled away from the paper together with the latex mask, which was next applied. The print was finally oiled with Naples yellow, and after an interval of several hours, the latex was stripped.

The print was then rubbed lightly to achieve a blending of the three contributory colors.

The most powerful color, lampblack, was also the driest at this stage and therefore the color least likely to contaminate the others excessively. (Controlled contamination or blending is the objective.) Payne's gray, the second color applied, is the second most powerful in terms of coloring influence. Naples yellow, the last color applied, is the least powerful and is susceptible to excessive darkening. There is some mutual subduing as the colors cross into each other. The yellow color can become too gray if the previous colors are still insufficiently dry. It is also true that the yellow (or for that matter, any yellow or any other light color with opacity) can fog the blacks and other dark colors. To correct this, the yellow (or any third or fourth lighter and brighter color) can be gently rubbed out with a cloth oiled lightly with linseed or some other vegetable oil. A completely dry cloth will probably not take away much of the fogging, so some oiling becomes necessary.

COMBINATION PRINTING

The chemistries producing Vandyke images (deep rust brown tones) and cyanotype images (pale to intense Prussian blues) are highly valued photographic printing methods in their own right. Each can also be used in combination and supplementally with the gumoil process with varying degrees of success. Because gumoil produces an image that is vastly more resilient than the other processes, and because it destroys previously laid down chemistries, the gumoil image must be printed first. The thin, water-based processes can then, with care, be applied over the well-dried and cured gumoiled paper with the objective of having them sink into the white (nonoily) spaces.

It is important that a gumoil print being prepared for combination printing be completely dried (for two to three months or longer) and that no fixative or varnish whatsoever should

have been used on its surface. The print surface will be resistant enough to the application and absorption of water-based photographic emulsions as it is because of the gumoil process without further "waterproofing" the surface with varnishes or oil coats. Development procedures will have little or no effect on the preexisting gumoil image. Gumoil is so hardy that it is difficult to imagine any known photographic process powerful or corrosive enough to have an effect on a gumoil under print.

The easiest method of making a combination print is to make a monochromatic gumoil and follow this with a full and comprehensive bleach etching of any residual gum bichromate layers. In this fashion, the oil paints will not have greatly contaminated any of the areas protected by the gum. As soon as the sheet is water-dry, it will thirstily accept the water-based sensitizing chemicals, making it unnecessary to wait for the oiled portions to dry completely. The blue- or brown-printing water-soluble chemistry subsequently applied will tend to soak into the tonal regions now that they have been nicely opened up by a thorough etching bath. The second emulsion lying on the gumoil print must be printed in registration, not with the positive film transparency but with its corresponding enlarged negative. Everything must have been printed in registration with the other relevant materials to make this work properly.

The required large negative can be made by contact printing the positive to a second sheet of film in the darkroom along the lines described in Chapter 3. The second (Vandyke or cyanotype) color printing, when developed, may be too dark, too intense. In this unlikely case, an extremely weak bleaching bath can be used to lighten the color slightly while you watch it carefully to guard against its becoming washed out. One part bleach to 50 parts water is sufficiently strong.

The relative contribution of the cyanotype or Vandyke printing color can be increased or decreased by manipulating the original latent gum image. If only a few black accents are wanted in a predominantly brown or blue picture, overexpose the original unpigmented gum print. An overexposed latent

image will accept relatively little lampblack oil color, leaving most of the print area, when stripped of its gum, readily accepting of the second emulsion. Underexposing the latent gum print, on the other hand, will result in a relatively strong (overexposed and overly colored) monochromatic gumoil with a proportionally smaller amount of open space for the second emulsion. The amount of work and planning necessary in combination printing suggests that only the most carefully selected images should be used for the most detailed, previsualized outcomes.

An essential characteristic of gumoil images is that they are textured and seem to lie in layers within and also on top of the paper on which they are printed. Vandyke and cyanotype, on the other hand, give the impression of being in the paper and add no particular substance or texture to the paper. It is the interplay of the different processes' flatness and texture that makes the combination print particularly interesting beyond the colors themselves.

Vandyke Process

Vandyke printmaking is a variation on the somewhat more elaborate kallitype process. (For the details of kallityping, see Crawford 1979, Hirsch 1991, or Stevens 1993.) Although the powdered silver nitrate compound required for Vandyke printing is expensive, a small amount goes a surprisingly long way, and in any event, it is far cheaper than its higher-priced cousins: palladium and platinum. The latter two, of course, can be used to produce a great range of tones, from richly attractive cool blacks to lovely warm browns. They can be also used in conjunction with gumoil printing, although the procedures are not discussed here. (For extensive information about platinum and palladium printing, see Crawford 1979 and Hirsch 1991.)

Vandyke is a printing-out process, which means that when paper coated with the emulsion (see Table 8.1) is held firmly in a contact printing frame under a registered negative, the image

Table 8.1 Vandyke Sensitizing Emulsion*

Silver nitrate**	37.5 grams
Ferric ammonium citrate	90.0 grams
Tartaric acid	15.0 grams
Water to make	1 liter, total

*Stopper and refrigerate the solution.
**Powder is easier to dissolve than crystals.

will tend to emerge and actually become visible under the glass as the sunlight is striking it. In overprinting a gumoil print with Vandyke chemistry, an enlarged *negative* is used to print or emphasize details that reside in some of the lighter and intermediate areas of the underlying gumoil print. Vandyke will have no effect at all on the darker portions of the gumoil print.

In very bright sunlight, an exposure of approximately 4 to 6 minutes is typical. The print should be floated in cool running water for several minutes of development as the image becomes richer and clearer. It can then be stabilized in a standard hypo fixing bath, without hardener, for a few minutes. It is finished with a 15-minute running-water wash. A highly diluted bleach bath will lighten the Vandyke portion of the print if desired after careful inspection. Although the procedures described are intended for combination printing with gumoils, they can also be used for straight printing on paper in Vandyke alone, a process that yields gorgeous browns that are, contrary to conventional photographic wisdom, quite archivally stable.

Stoppered and refrigerated, the Vandyke chemistry lasts a very long time. The liquid, stirred each time it is used and strained through cheesecloth if necessary because of undissolvable particles, is used for coating directly on the paper surface. In yellow bug light or subdued tungsten light, use a foam brush, prewashed and prewetted, to stroke the liquid evenly onto the paper. The liquid is quite thin and easy to apply, but it tends to

Table 8.2 Cyanotype Emulsion*

Solution A	
Ferric ammonium citrate	50.0 grams
Water	250.0 cubic centimeters
Solution B	
Potassium ferricyanide	35.0 grams
Water	250.0 cubic centimeters

*Stopper and refrigerate solutions A and B separately and mix in *equal* parts to produce the quantity desired for a printing session.

pool and bead, especially at the edges and bottom of the sheet after it is hung to dry. Use a bit of paper toweling clamped onto the lowest corner to drain off the excess. When the Vandyke-treated gumoil print is dry, it can be placed in registration with the large *negative* and exposed in the sun.

If all this works, rich brown details, especially in the light and middle tones, will be added to the existing gumoil print.

Cyanotype Process

The cyanotype emulsion (see Table 8.2) is applied just like the Vandyke. You brush it onto the paper and hang the sheet to dry, while paying attention to the streaks and drips. Cyanotype emulsion, like Vandyke, is extremely staining and can leave the floor and walls of your darkroom a mess, which is very difficult to clean up. When the paper is coated and dried, the length of exposure under the enlarged *negative* is greater by a magnitude of 3 or 4 or more to 1 compared with Vandyke. It is also a printing-out process. The print should be washed thoroughly in running water. Clearing the cyanotype after printing is desirable, but fixing in the usual (silver) sense is unnecessary. Clearing will more quickly bring out the print's brilliant blue and can

be accomplished with a brief drenching in a bath made of 1 ounce of hydrogen peroxide mixed with 20 or so ounces of water. Hydrogen peroxide speeds the supply of available oxygen to the process. Discard the bath before it stops working. Wash the cleared print for a few minutes and hang it to dry.

As with Vandyke, you will choose cyanotype for its distinctive and specific chromatic contribution to the basic, and more dominant, gumoil print. Or you may enjoy printing with it alone.

Considerations Relevant to Both the Vandyke and Cyanotype Processes

Bottles of Vandyke and cyanotype emulsions will keep for months, if not years, when stored correctly. Both emulsions are toxic. Always stir emulsions vigorously before using. If a sediment forms that cannot be redissolved, strain the liquid through a few thicknesses of cheesecloth and rebottle.

Both emulsions are best applied by means of a reusable and washable foam brush. Avoid making streaks or leaving drops. While the emulsions are not extremely light-sensitive, it is best to prepare and handle them under a yellow bug light and to store the coated paper, if you must, in a fairly lightfast drawer for a few hours at most before using. The coated paper should be bone dry before printing is attempted. Prints should be washed promptly after exposure and hung to dry. If they curl, they can be flattened for a few minutes in a moderately hot dry mounting press between protective paper sheets. When you have done all this, you can varnish the combination prints if you wish.

Combination printing, whether with Vandyke or cyan, only makes sense when the underlying gumoil print is relatively weak or pale. If the gumoil is strong and dark, there will simply be no opportunity for these other printing chemistries to make a contribution. Consequently, there are two strategies that you

can follow in printing with these methods. The first is to set aside gumoils that turn out by accident to be weakly printed. They may well be saved by overprinting (though, of course, they can also be overprinted again with gumoil). The second is to set out deliberately to print lightly colored gumoils that you think will produce a highly satisfying result when joined with a second chemistry—one that adds brown or blue depth and detail to the original.

9

Other Considerations

PRINTING POSSIBILITIES
FOR THE FUTURE

Prior to this chapter, tube oil paints have been the only coloring medium assumed to work for gumoil printing. Although tube oil is a most convenient vehicle for applying oil-based pigments, it is not the only effective working material. There are at least two other oil-based pigmenting materials to be considered—the oil stick and the oil pastel stick.

Oil sticks or oil bars are made by several manufacturers, and one or two varieties will be available at any art supply house. The solid, but definitely oily, chunks of pigment can be directly applied by hard rubbing onto most surfaces. They work on paper without difficulty, but they have no clear advantage when compared to a tube of oil color. Oil bars are so solid that they are rather difficult to apply thoroughly over the wide expanse of a gumoil print—say, 12 inches × 12 inches. The bars are like giant crayons, soft enough to apply a band of color, but not

buttery enough to fill in all the gaps and cracks. Consequently, if you use an oil bar, it may also be necessary to rub a little linseed oil over the whole colored area to make the pigment penetrate the paper thoroughly. Like tube paint, oil bar pigments will be resisted by the gum and, conversely, accepted by the paper where there is little or no gum. The bars can be used in monochromatic and polychromatic gumoil printing, inclusive of repeated coloring, bleach etching, and washing.

Oil pastel sticks are made by Sennelier, Holbein, and Sakura. Like the oil bars, pastels can be worked into the paper's fiber, and the gummed areas will tend to resist them. Various metallic and iridescent colors are also available in tubes, bars, and sticks. The pastel colors in some cases may be more luscious or delicate than conventional tube oil paints, and this fact alone may be a sufficient reason for using them. Otherwise, there is no obvious advantage in using either oil bars or oil pastels for applying pigment except that in doing so, the printer can eliminate the clotted brushes, which require periodic cleaning; the tubes, which become filthy and must be stored; and the jars of standing oil, which are prone to spilling. The challenge for alternative coloring methods is that they must be robust enough to withstand repeated bleach etchings and washings.

Alkyds are another print medium. They are oil-compatible resin-based paints that have some advantages over conventional linseed oil–based paints. They are less yellowing, the colors are brighter and cleaner, and they are faster-drying. It is this last consideration that makes alkyds potentially attractive for the gumoil artist. With alkyds, it may be possible to shorten the overall length of time now required to produce a final print.

Even though the name of the method is *gumoil*, it is actually possible to make a satisfactory print without oil-based paint. Acrylic paints can be forced to work in this process. Perhaps prints pigmented in this fashion should be called gumacrylics. They must be processed quickly to circumvent their inherent tendency to dry very rapidly, making the paint impossible to

remove from the gummed surfaces. In practical terms, this means application, rubbing in, and clearing off in moments. Acrylic retarder or acrylic medium dropped onto the fresh paint surface and wiped off with toweling might serve to slow the drying process and lubricate the removal process, respectively. Neither has been tried by the author. The objective, however it is achieved, is to get the excess color off the gummed surfaces as quickly as possible, without pulling the color out of the open paper areas. It can be done, but not with the leisurely deliberation that characterizes the gumoil process. The vastly increased drying speed of acrylics could mean there is a potential for making far more prints in a much shorter period of time than is possible with the oil-based process.

Gum arabic serves as a versatile resist to most any pigmenting method you might choose. Pencil, charcoal, marking pens, house paint, ink, and even watercolors might turn out to work with the process of gumoil printing if the artist is resourceful enough to make the necessary adjustments.

If there were a way to add an emulsified oil component to the sensitized gum, and keep it in colloidal suspension until dried, then the subsequently exposed, developed, and hardened gum might prove to be an exceptionally effective resist to such water-soluble paints as acrylic, watercolor, and gouache.

Chapter 2 contains several possibilities for obtaining imagery that may be suitable for transfer to large transparent sheets. The images chosen for printing might or might not be camera-originated and might or might not be rephotographed on ortho litho film sheets. Any positive image laid upon any relatively transparent surface (film, thin paper, acetate, glass, plastic, etc.) can be printed in the gumoil process. Photograms reminiscent of photography's earliest days are possible in gumoil by pressing thin three-dimensional objects such as leaves, lace, and string against the sensitized paper while exposing it to sunlight. Many of these ideas have implications for future directions and experimentation.

PRESENTATION OF GUMOIL PRINTS

The gumoil print is unique. How best to present it requires some consideration. Most fine art photographs are matted between high-quality museum boards. The board and other materials such as tape, mounting corners, and dry mounting tissue must be acid-free and register a neutral pH. Gumoils should also be treated this way.

For exhibition purposes, matted prints are framed and sealed under glass. When a gumoil is covered with glass, however, it loses some of its character because the surface and texture can no longer be seen properly. The same may also be said for some other photographic processes. Three-color carbon, gum bichromate, and platinum/palladium prints all suffer visually when they are protected with glass. You will recall that the gumoil process has been described in previous chapters as extremely hardy. Indeed, if it gets dusty, the surface can be sponged off with absolutely no negative effects. Some serious thought should be given to exhibition framing of gumoils without facing them with glass at all.

There is also a question of how the gumoil print should best be matted. The edges of gumoil prints can graphically show the process and its component colors and thereby distinguish prints made by gumoil from other photographic printing methods. *Pitcorthie Tree with Parasite* (Color Plate 2) is an example of what a print looks like with its processing edges exposed. In favor of showing edges is the argument that it informs the viewer about the process and may also make an aesthetic contribution to the overall effect of the print. It is more or less analogous to the practice in some other photographic methods of showing brush coating marks. Platinum/palladium and cyan printers frequently do this.

Arguments against exhibiting gumoil's print edges are equally persuasive. Showing edges calls too much attention to the method, and one wonders whether the photographic work can stand on its own without the extra assistance. Showing

edges is somewhat flashy and gimmicky and detracts from the picture's merits. Another approach is to tape or ink the borders of the large positive transparency. The margins of the print will then be black after the first application of lampblack oil following development of the latent gum print.

Beyond the issues of matting, framing, and edging, there is the option of mounting (perhaps gluing) the gumoil print directly onto a piece of wood or some other flat, rigid support surface. This composite, in turn, might be framed or not. Such treatment would tend to move the gumoil print further away from the traditions of photography and in the direction of the way paintings are exhibited.

SELLING AND PUBLISHING GUMOILS

Most serious photographic artists are interested in making prints for a wider public than themselves, their relatives, and an occasional appreciative friend. Whether you intend to make gumoils or use another process, you need to evolve a strategy for promoting your work. The operators of galleries and museums, let alone the art buying public, are mostly uninformed about alternative photographic printing processes. Consequently, alternative photographic printers have a large educational job ahead of them. And of all the arcane processes, gumoil as the newest one will be the one least understood and will be most likely to be confused with other unusual processes. Gallery owners are often attracted to the prints but may hesitate because they defy categorization. After all, there is a question of whether they are primarily photographs or paintings. (The answer is that they are primarily photographs.)

If you want to sell prints, rather than simply exhibit or publish them, two obstacles loom. The first is that the prices will have to be high to compensate for the length of time and the considerable effort required to make just one acceptably fine

print. If you are not already well known, commercial acceptance may be slow. The second obstacle is that making one or more true duplicate prints is virtually impossible without a great deal of experience. There are too many variables for the printer to control. Approximate duplicates are feasible, but only with a great deal of effort and many wasted prints.[1]

Related to this second obstacle is the attachment a creator forms for gumoil prints, partly because of the effort expended, but mainly because of their uniqueness. If a print is especially good, it becomes all the more painful to let it go. It is also far more difficult to approach true duplicate printing quality if the first print is gone and only notes and a color slide remain.

Publication and exhibition are not likely to be lucrative, but they are feasible means of sharing your work with a larger audience. Gumoil is new, unusual, and capable of making beautiful and interesting prints. If your work in the medium is good, publishers and exhibitors will be intrigued. Teaching, through workshops or college classes, is an excellent way to share your talent and to be stimulated by others. No opportunity for getting critical feedback should be missed.

NOTE

1. The author recently exhibited a single gumoil print in a benefit sale at a photographic gallery. When the owner called to say that three prints had "sold," panic ensued. In order to obtain a finished group of almost identical prints, this gumoilist started off with ten sheets of sensitized paper. He performed, so far as possible, the same operations with each one, from sun exposure (all exposures were done in the same day within the same hectic hour), development, masking, three oil paint applications, and three bleach etchings. Tiny variances in length and strength of etching, primarily, led to seven unacceptable prints and three decent ones. It took almost three weeks to produce the three prints.

10

Advances in the Gumoil Process

This chapter surveys what is new in the art and science of gumoil photography. That, and the addition of several new color plates made from computer-generated interpositives, justified a revised edition of the original. I have learned several new things about gumoil printing since the book was published in 1994. The most important of these is the use of digital technology for making the interpositives required for contact printing onto sensitized, gum-coated, watercolor paper. There are also new things worth mentioning about exposure, washing, and pigmenting. My goal is to share as much as I can about this mysterious and extraordinarily versatile process which is part photography, part print-making, with the balance made up of improvisation, intuition and luck. I have chosen to write this chapter in the first person as a personal footnote to the first edition.

THE COMPUTER

It may seem somewhat contradictory to readers of a book dedicated to creating images in the Pictorialist tradition to learn now that computers have a serious and even pivotal role to play in these early processes. In fact, the fundamentally Nineteenth Century print-making technology I've termed polychromatic gumoil can be improved upon by incorporating modern computers and software. Those of us who prefer hand-crafted, evocative images tend to regard (quite correctly) computer-mediated graphics as mannered, gimmicky, and far too dependent on special effects and odd compositions such as dogs balanced on balls, and the like.

In 1994, soon after the publication of my book, I wrote the following to a computer expert: "Can I take a strong computer-mediated image, with sound tonal values, and contact print it onto sensitized material with useful results?" The implied question was whether such a computer-made interpositive could effectively substitute for the labor-intensive, darkroom film enlargements described in Chapter 3. I was fantasizing about the day I would no longer have to stand in total darkness for 15 minutes or more sloshing a tray-borne sheet of ortho-litho film, tortured in equal parts by suspense and boredom.

What if I could see via a monitor how the picture would look, size it appropriately, alter contrast as necessary, correct errors and in other ways adjust the outcome and do all this cheaply and easily? The short answer to all of this was yes. It should be possible, I was told, to accomplish all these things and maintain high quality of the final image. How this was actually accomplished follows and will serve, I hope, to draw more people into making gumoil prints who either do not have access to a darkroom or who merely dislike darkroom work, begrudge the time required, or who simply find the chemistry obnoxious. It also turned out to be possible to eliminate or minimize errors inherent in the original film negative, improve the interpositive and print it quickly without the huge investment of time, energy, and materials darkroom enlarging requires.

None of the information in this chapter is particularly technical and will be fairly elementary for those who are already familiar with computers. Examples will be based on my equipment and experience. I recommend the publication by Rich and Bozek (1995) as helpful for scanning black and white images and the more comprehensive book by Ihrig and Ihrig (1995) which deals with color and monochrome (gray scale scanning) in depth. I confess that my own approach to using computers was simply to wing it. I loaded the program (Adobe Photoshop 3.0) and struggled with manuals, machinery and my own limitations to produce enlarged black and white interpositives printed on various materials. I began by making poor, then acceptable and finally, some excellent interpositives. An excellent interpositive is, of course, the one which leads to an excellent gumoil print. The interpositive itself may not be particularly pleasing. As noted elsewhere, Figure 6 to Figure 10 are all made from such computer-mediated interpositives. They are indistinguishable from gumoils printed with darkroom-enlarged, chemically-developed, film interpositives. The reason for this is simple. The gumoil process does not require the resolution and fineness needed for a silver or platinum print. Gumoil is forgiving and the tiny lines and dots associated with digitally-rendered images are dissolved in the gumoil process.

1. THE EQUIPMENT AND SOFTWARE

None of what follows is intended as a testimonial for particular equipment or software. I will simply describe what I use and have found satisfactory for the purpose of making enlarged positive images printed on either plastic or paper which then serve adequately as interpositives for the gumoil process.

The Computer: Power Macintosh 8500/120 with 80 megabytes of RAM

Recent upgrades to a 233mhz processor and 336 megabytes of RAM produced some improvement in performance but the earlier configuration worked nearly as well.

The Printer: Hewlett Packard 4MV Laserjet

This prints only in black and white and handles anything up to tabloid size paper (11 × 17 inches). You will need another printer if you want both color and black and white that can produce this size page. I have an Epson Stylus Color 3000 for that purpose but generally prefer the speed and reliability of the Hewlett Packard laser printer. If you are content with images no larger than standard letter size, then dozens of fine printers are available.

The Scanner: UMAX/UC1200 flatbed scanner with transparency adapter

True optical resolution 600 × 1200 dpi (maximum interpolated resolution 2400 × 2400 dpi). External Image Storage: Zip Drive, with 100 megabyte disks. (In retrospect, a system with even larger storage disks, such as the Jaz, would have been preferable because I would have fewer disks to deal with.) If you do not generate hundreds of images yearly for printing in the alternative processes, an ordinary Zip Drive system should suffice. An auxiliary hard drive would be fine from a storage point of view, but it is not portable. With Zips, I can work on images in my studio, the iMac in the bedroom, or the G3 Laptop I ferry between home and my large-format studio a few miles away.

Image Program: Adobe Photoshop

This seems to be the most versatile program for monochrome and polychrome image manipulation. I have used versions 3.0, 4.0, and 5.0. Any of them is satisfactory for the preparation of gumoil interpositives.

2. GETTING THE IMAGE INTO THE COMPUTER

I assume you will use your own film-based work (rather than draw upon the millions of images available commercially on

compact disks and elsewhere). There are two basic ways of getting a film negative (black and white or color) or positive (color slide or print) into the computer. You may scan the image yourself or send the negative/slide to a scanning service and pay for it to be professionally scanned to a CD which can then be read into the computer. Thus, whatever computer system you use, you must either have your own direct scanning device or a CD reader connected to the computer, or both (as in my case). If you scan your negatives or transparencies you will need a flat bed scanner with a transparency adapter. Get the best one you can afford, the one with the highest optical resolution. The same scanner can be used, with the transparency adapter turned off, for scanning conventional prints. If they are in color, they can easily be converted to black and white in the computer. These are called reflective scans. High quality transparency scans can also be made in the home environment by means of more expensive transparency scanners such as those made by Polaroid, Leaf, Agfa, and Nikon. The point here is that no matter how you persuade your computer to acquire an image, a program such as Adobe Photoshop can then transform it from color into black and white, from negative to positive, and vice versa . . . with a simple command.

In the computer world everything is a compromise, no matter what you spend, because there is always something better, bigger (and more expensive) than what you have. I have found it satisfactory to stay with a flat bed scanner to scan negatives 6×6 cm and larger. I make my final scan at a high resolution and reduce it later to correspond to the limits of my 600 dpi (lpi) printer. Ultimately, I want to end up with an image stored on a Zip-type disk in a size ranging from 5 megabytes at a minimum up to 10 or 12 megabytes depending on the final dimension in inches I want. For example, I may want the image to be expanded to, say, 10×10 inches for square format or 9×13 inches for rectangular. Or even larger. If one tries to use scanned images of much more than 15 megabytes, however, the computer will slow significantly while adding little of value (for gumoil print-

ing) to the final result. If you want to make composite inter-positives (those with more layers and image components) larger files become necessary and you will have to deal with it ultimately by adding RAM and Hard Drive capacity.

Another way of stating this is that I generally choose a final resolution size of about 275 to 325 pixels per square inch (ppi). Adobe Photoshop expresses the resolution under Image>Image Size. Although Platinum and Silver printing from such negatives requires very high resolution, alternative processes such as Vandyke, Cyanotype, and conventional Gum Bichromate can easily be made in high quality editions from ordinary computer generated images.

I prefer to send my 35 mm negatives and slides to a service center for professional scanning. See the Annotated Suppliers List. This is because I have found that my flatbed scanner/adapter cannot produce sufficiently high resolution in the 35 mm size. In any case, it is quite reasonable to have them scanned commercially (about $1.00 per scan at today's prices plus the cost of a CD which holds up to 120 individual scans). It is also convenient to have Kodak CDs which come with a picture index, a set of folders for each image in five different degrees of resolution and a "slide show" which makes it easy to review the images quickly by thumbnail images. More customized scanning is available for 35 mm or larger sizes for a higher price. I find the prices for large negatives too high so I generally scan with the flat bed, via the transparency adapter, any 6 × 6 cm or larger negative. The guidelines for file sizes given above apply also to 35 mm images. In other words, stay with files no larger than 15 megabytes unless you are printing in another medium than gum, gumoil, Cyanotype, or Vandyke.

Be aware that the commercial scans (Kodak system) of black and white negatives come in "color" and that color information must be thrown away when dealing with the image. Do this first thing by going to Mode>Gray scale; this will greatly improve your computer's efficiency.

3. ENHANCING THE IMAGE INSIDE THE COMPUTER

I use a program like Adobe Photoshop because one can do anything with it to enhance the photographic image that can be done in the darkroom with an enlarger. That includes, but is not limited to, burning, dodging, altering contrast, and sizing the final image. Leaving aside some other elaborate manipulations, here are a few basics to take a good image and render it as a paper or plastic interpositive which will, in turn, make a good gumoil print:

a. The program Menu will allow you to size the picture under Image Size. You can make sure it will come up in black and white positive format and in the megabyte range you want and the actual inches size you want to print the final interpositive. Be sure to go Grayscale under Mode. This allows you to discard the unnecessary color information and reduce the file size which will help save you time on the computer and the printing.

b. Use Image>Adjust>Levels, a histogram of darks and lights to make sure that you have an image with strongish contrast. Squeeze the whites down and push the blacks up. In other words, compress the tonal range, keeping some pure white and pure black at either end. All of this has to be done by visual inspection and learning how to translate the screen image (always brighter than the paper print out) into an image that will print well in gumoil is a real challenge. I curtail the whites, but do not eliminate them. I intensify the blacks . . . they usually need it. And sometimes the intermediate tones need moving about. All of this can be done with little cursors on the graphical presentation obtained with the Adjust>Image>Levels. The same effects can be achieved, but less intuitively, with the menu selection Image>Adjust> Curves.

c. Use the program's burn and dodge tools on the Palettes menu to enhance values of the image. This is a trial and error sort of experience that you have to do over and over to achieve mastery. Basically, gumoil interpositives need punching up. They need more contrast and more definition (unlike, for example, what a platinum print might require). Very strong, slightly exaggerated black and white images in the interpositives then get toned back down in the gumoil process. In a nutshell: you can take a black and white negative, bring it up on the screen as a positive image, and print it on paper or plastic and have quite a nice picture. But, it will not necessary print well as a gumoil. Usually, you will need a more exaggerated image to print nicely in gumoil. Photoshop also allows the photographer to eliminate flaws in the image. Some negatives seem to be lint or scratch collectors. Photoshop is brilliant for the ease with which these flaws can be removed. Similarly, a car in the distance may mar an otherwise perfect picture. Eliminate it. Or, it may be that a sky is too open and would look (print) far better with a cumulous nimbus cloud. This is far more technical but just as possible. One can insert an ideal cloud bank to fill the space behind a building, a tree, a statue. This is getting into typical computer art manipulation and I generally find it objectionable and avoid it. Still there are those rare occasions where a picture can be really saved by adding an element such as clouds or a tree or adding the missing cross on a steeple.

4. INTERPOSITIVE MATERIAL

I had originally assumed it would be necessary for interpositives to simulate photographic film, that is, to have a range from transparent to opaque. I went to some lengths to purchase custom-cut sheets of Mylar "Type D" Polyester which would be printable on my HP 4MV laser printer. Another assumption I made was that I might also want to use "vellum" type paper for the interpositives in order to get better transmission of light. It turns out that all

that is needed is the most ordinary and cheapest computer paper. The cheaper and, therefore the more translucent, the better. A good image, strongly printed in black and white, on regular computer paper, can be contact printed to make a gumoil image equal to one which comes from a conventionally enlarged photographic film sheet developed in a darkroom.

Consider the advantages. Paper is cheap and the rejects can be recycled. In a few minutes it is feasible to make several computer generated images of various contrast values which can then be visually inspected and one or two chosen to print in gumoil. Consequently, I have not made a film interpositive with photo chemistry and the enlarger since the day I brought my computer/printer/scanner home. Other alternative print making processes can also benefit from the computer. Specifically, I have made enlarged paper and plastic negatives to contact print in Vandyke and Cyanotype. Plastic negatives are significantly more successful than paper when it comes to Vandyke and Cyanotype. I am less likely to attempt a platinum or silver print with a computer generated and enlarged negative. More and more people are currently doing just this, however.

Once the computer-generated interpositive is printed out on paper it can be used precisely the same way as a film interpositive. Paper positives do require slightly more exposure to ultraviolet radiation than film. If an Aristo Platinum Printer box is used this usually amounts to a matter of one or two additional minutes. The small additional exposure time is due to the opacity of the paper versus transparent film.

Paper is amazingly versatile. You can tape together related images, or different views of the same subject, and contact print these collages. I frequently add marks or emphases with brushed washes or black penciling to improve definition on the interpositive and, eventually, the final gumoil print.

5. OTHER COMPUTER APPLICATIONS

a. Few personal computer printers can handle anything significantly larger than the tabloid-size paper needed to produce

images of about 10 × 10 or 10 × 14 inches. I generally size my rectangular images at 8.5 × 12.75 inches, 288 pixels per inch and a file size around 9 megabytes. If one wants to make square or rectangular images larger than this it is a relatively straight-forward matter to transport the image, after improving it, via a disk (e.g., Zip or Jaz) to a local graphics company which has a bigger printer. I have taken images from the computer (using the same resolution range described earlier) on a Zip disk and instructed the company to make enlarged transparencies of dimensions such as 18 × 24. Printing these bigger images requires a good deal of advance planning and effort. See the section below on Further Advances.

b. Giclee (Iris, or ink jet) printing of gumoil originals. There are only a few companies in the U.S. that truly know how to make fine reproductions of original art images. They do this with very expensive drum printers, multiple ink jets, expert computer work and enormous care. They scan the original art with advanced technology (beyond what one can have at home or what one would expect from service centers).

They print on fine watercolor papers and produce spectacularly true results. Thus, it is possible to take an image in gumoil which is unique and unreproducible by the artist, and produce an edition of identical prints of any size. What makes a good printer distinctive from a mediocre printer is choice of paper and textures, accuracy of color, and preservation of resolution. I have had made reproductions made in limited ink jet editions which I number and sign.

SOME OTHER CONSIDERATIONS

1. Paper. The Fabriano papers remain the best for the gumoil process. Fabriano Artistico and Fabriano Uno both work very nicely. Some other papers work but are often problematic in particular applications. This leaves Fabriano the preferred choice. The only reason to use others is experimentation or availability problems.

2. Picture edges. The appearance of my gumoil print edges were so unpredictable I generally matted them right up to the image itself rather than show the process edges. If you want to show something beyond the image, however, it is important to factor this in at the time you coat the paper with gum. Make a template roughly the size of the inter-positive. Then coat within the cut-out template. This will insure approximate coverage of the actual image and interesting edges (in black or whatever the first oil color is used) if you apply the oil paint beyond the gummed borders. Color Plate 6 illustrates such edges.

3. Oils. Oil colors, their makes and their qualities are incredibly diverse. I urge gumoilists to use Windsor and Newton Lampblack for the first print layer. Occasionally other colors will work, but Lampblack is the most satisfactory first printer and has been used in all the examples shown in this book. Subdued colors are usually the most successful in the successive applications. For example, Warm Gray, a Rembrandt brand oil color works exceptionally well as a second or third color layer. Naples Yellow, a creamy yellow, is an extremely dense color (requires much rubbing off . . . often with a drop or two of oil to facilitate clearing) that I frequently use to fill in sky or other background, often using liquid masking to isolate the color. Reds are especially tricky. They tend to be thin (very non-covering) and much slower to dry than blacks and browns. I have recently started using a Cadmium Red alkyd medium made by Windsor and Newton (for faster drying) to which I add powdered red pigment to make the paint more dense. This may dry too fast for some printers, so another option is simply to add the powdered pigment to straight oil media. I will often use a light color such as Naples Yellow, Cadmium Yellow, or Yellow Ochre as the color to follow an intense red. The red must be very dry unless one plans to have an orange-tinted picture. There is a comparable drying problem with dark blues.

I often mix pigments. In order to get a yellowish, khaki color (useful for landscape backgrounds) I combine Sap Green, Naples Yellow, and Raw Umber. Daniel Smith makes a nice Violet Umber but I often intensify it with additional violet oil color. This produces a mauve or even amethyst color. When I get a particularly satisfactory color I make written notes about it and store the surplus in an air tight container.

It is safe to say that every oil color will transfer, though perhaps only to a small extent, to the next color layer. Black to brown, black to blue, makes little observable difference. However, if the second level is blue and yellow the third, care must be taken not to end up with a green image.

4. Washing. Aside from getting the exposure time right (via the sun, platinum box, mercury vapor lamp, or a sun tanning lamp) the initial washing during development can easily be over-done or underdone. The latter produces too much black and few highlights. The former results in the reverse. Neither result, if pushed too far, can be corrected enough to produce a good final print. Experience will tell you, eventually, when an image cannot be saved but should be recycled. Correct washing (usually about 12 minutes) can only be determined by inspection. There must be sufficient residual gum to serve as a robust resist. At the same time, the open spaces must be clear or white enough to accept the oil paint. It is not necessary to run water continuously. Simple soaking with occasional spraying will clear the gum from the "white" spaces. It is, of course, the white spaces in the dry gum print which should absorb the black paint and the yellowish gummed spaces which should resist the paint.

5. Exposure. Correct exposure depends on the proportional mix of gum and potassium bichromate, the paper on which it is brushed, and the light source. Experimentation is essential as no hard and fast rules exist across every situation. I have found that a mix of one part saturated (warmed to

maximize saturation) potassium bichromate and distilled water with three parts liquid gum arabic works best for me, my climate, my interpositives, and my images. The mixture is spread evenly by means of a sponge brush on high quality paper and dried thoroughly. Good results can be obtained if the sensitized paper is placed in dark storage and used within 48 hours or so.

6. Etching. The etching, first or later stages, seems to be best accomplished in a water to bleach ratio of six to one. Bleach can be added as it becomes exhausted. Times are very tricky to recommend. Sometimes extra time in the etching bath is needed as well as brushing and a good deal of direct water spraying. Inspection and experience are essential.

FURTHER ADVANCES

Due to the limits of my workshop's size and the trays it can accommodate, the work surfaces and so forth, I have kept my pictures to maximum sizes of about 12 × 12 inches and 12 × 18 inches. Even these sizes pushed the limits of my exposure box, trays, and counter work space. Smaller pieces were more comfortable to make because it was easier to manage the work and took less labor.

Two years ago I began to make gumoils in larger sizes by using sunlight as the UV source, a huge contact printing frame, a garden hose and sprayer, and big trays laid out on the ground. I had some good results, but it is back-breaking work. In short, printing bigger requires a larger contact print frame, far more work space, larger trays, more water, and a great deal more physical work as one applies paint, rubs off, bleaches, washes, dries, and oils again. Still, the results were encouraging and galleries often want the large sizes. I have now made several giant gumoils. Even images approaching 24 × 30 inches can be satisfactorily made with interpositives enlarged from 35 mm or 6 × 6 cm negatives. The procedure I now follow is to work on improving the image on the computer, transfer it to a Zip disk, and de-

liver it to a local commercial digital imaging center. The center enlarges the image to the desired size, usually on plastic. Because this is ink jet technology (rather than laser) care must be taken not to wet the interpositive on its inked surface—it will run. From this point on exposure and printing remain the same.

I have found it so satisfying to work in the larger formats that I built a completely new studio geared to the larger dimensions. It is equipped with an out-sized ultraviolet light source (a mercury vapor silk screen burner), a big coating and drying cabinet with an exhaust fan, an eight-foot long by four-foot wide sink, over-size trays, long and deep counters, and some spacious hanging and drying areas.

A LAST WORD

Some argue that print-making technique must be subordinate to content and composition. I suppose that is true but it is also a fact that technique is enormously important in how we interpret an image in the printing stages. The result of that interpretation, in turn, profoundly affects how the image is then seen by others.

Sometimes it may be appropriate for the process to take a back seat and be treated as almost incidental to the image. In such a case it may be desirable to mat up to the edge, stay with blacks and grays, and avoid flamboyance. But there are other images which thrive on a more dramatic presentation. These images benefit, it seems to me, when the process edges show and the colors used are bolder.

Appendix

GUMOIL PRINTING SUMMARY

Monochromatic Sequence

1. Choose a black-and-white negative with adequate con-
trast and tonal values.
2. Make an enlarged positive film transparency with
the same or slightly greater qualities of contrast and
tonality.
3. Mix a 5 percent potassium bichromate sensitizer solu-
tion, bottle it, and refrigerate.
4. Mix 1 part of the sensitizer with 3 parts liquid gum and
refrigerate the mixture when not using it.
5. Coat high-quality, heavy watercolor paper with the
unpigmented gum. Dry completely. Expose the coated
side through the transparency and develop in running
water. Dry completely.
6. Brush in the first oil color (usually, lampblack) vigor-
ously over the entire surface of the print and wipe off

129

well after 15 minutes or so. At this point, the print may be considered finished, with or without bleaching, with or without varnishing.

Polychromatic Sequence (Two Colors)

7. Etch the print obtained in 6 in a solution of 1 part bleach to 4 parts water within the first 12 hours of oiling to open new areas for a second color.
8. (2 to 5 days later) Brush in the second oil color and wipe off the excess. Finishing with varnish is optional. Do not finish if moving ahead to step 9.

Polychromatic Sequence (Three or More Colors)

9. After completion of step 8, wait up to 12 hours. Etch the gum around the residual second color with fresh bleach solution, wash thoroughly, and dry. This etching may take much longer.
10. (2 to 7 days later) Brush in the third oil color and wipe off the excess.
11. (after 1 to 12 hours) Etch away more of the remaining gum with fresh bleach solution, wash, and dry. This etching will take more time, water pressure, and brushing.
12. Repeat steps 10 and 11 for each additional color layer.
13. (after a week or more) Either leave the print in natural soft matte finish, rub in linseed oil, or apply thin coats of spray varnish in matte or gloss finish, but print must be dry.
14. See the main text for masking and other manipulations of the gumoil process.

Annotated Bibliography

Beaton, Cecil, and Gail Buckland. 1975. *The Magic Image: The Genius of Photography from 1839 to the Present Day.* Boston: Little, Brown.

> A moderately helpful encyclopedia of photography Some useful information and reproduction of early work. Poor print reproduction quality.

Blacklow, Laura. 1989. *New Dimensions in Photo Imaging.* Boston: Focal Press.

> A step-by-step introduction to many nonsilver photo processes.

British Photography: Towards a Bigger Picture. 1988. New York: Aperture Foundation.

> No listed author, out of print, and hard to find. Beautifully reproduced photographs, black-and-white and color, and mostly

modern. Find it if you can. (The ISBN for the clothbound edition is 0-89381-341-9.)

Buchanan, William. 1992. *The Art of the Photographer J. Craig Annan.* Edinburgh: National Galleries of Scotland.

> A show catalog of Annan's seminal work in pictorialism. He was considered by Stieglitz his equal, if not more. Good historical treatment and good reproductions of beautiful and not well-known prints.

Crawford, William. 1979. *The Keepers of Light: A History and Working Guide to Early Photographic Processes.* Dobbs Ferry, N.Y.: Morgan and Morgan.

> Without further qualification, this is the most useful and comprehensive guide to alternative photographic processes since Henney and Dudley's 1939 handbook. Good illustrations, good instructions. Morgan and Morgan says it will continue to print this book. Buy it!

Focal Encyclopedia of Photography. 1965, 1993. Boston: Focal Press.

> Full treatment of many of the early printing processes as well as later ones. The gumoil technique is too new to be included in the 1993 edition.

Henney, Keith, and Beverly Dudley 1939. *Handbook of Photography.* New York: Whitlesley House.

> Dry in the extreme, and no photographic illustrations at all, yet it is complete in its coverage of technical knowledge up to the start of World War II regarding the then-modern and the pre-modern photographic film and print processes. Materials suggested are quite dated, but it can be very useful nevertheless.

Hirsch, Robert. 1991. *Photographic Possibilities: The Expressive Use of Ideas, Materials, and Processes.* Boston: Focal Press.

> Now that Kent Wade's book (see this list) is long out of print and increasingly difficult to find, Hirsch's book is a gift from the gods of photography. He covers virtually everything in the way of

technique and equipment not found in the manuals of conventional photography and does it well.

Hirsch, Robert. 1993. *Exploring Color Photography*. 2d ed. Dubuque, Iowa: William C. Brown.

> This fine book covers every conceivable type of color printmaking process, including gumoil, and contains a large number of images, chosen imaginatively by Hirsch and brilliantly reproduced.

Jay, Bill. 1974. *Robert Deniachy: Photographs and Essays*. New York: St. Martin's Press.

> Hard-to-find book with less than memorable reproductions of prints by this master of early pictorial photography. Good scholarship, helpful technical information, and lots of reprinted primary source material. Bill Jay has subsequently written other fine books on early photography.

Johnson, Chris. 1986. *The Practical Zone System: A Simple Guide to Photographic Control.* Boston: Focal Press.

> There are other good books on the zone system, but this one is short, sweet, and simple. The gumoil print process depends heavily on good tonal range, something that the zone system can help with.

Koenig, Karl P. 1991. "Gumoil Printing: Monochromatic and Polychromatic Techniques." *Darkroom and Creative Camera Techniques* (September-October), 12 (5): 50-53.

> This is the first explication of the full gumoil process and the associated bleach etching techniques that allow for polychromatic printing.

Koenig, Karl P. 1992. "Van Dyke Printing: Monochromatic and Polychromatic Techniques." *Darkroom and Creative Camera Techniques* (May-June), 13 (3): 24-27, 58.

> Among other things, this article describes a way to combine the versatile gumoil process with the richness of Vandyke printing.

MacClean, Hector. 1898. *Popular Photographic Printing Processes.* London: L. Upcott Gill.

> Almost 100 years old at this writing, MacClean's work remains no less valuable reading for the serious photographer than it was at the turn of the century. His contributions on "fashion in photoprinting," albumenizing paper, pigmented gum printing, and salted papers have timeless value. Ask your art college librarian for it.

Nadeau, Luis. 1985. *History and Practice of Oil and Bromoil Printing.* New Brunswick, Canada: Atelier Luis Nadeau.

> Nadeau privately publishes his work, and it can be ordered by writing him at P. O. Box 221, Station "A," Fredericton, New Brunswick, Canada E3B 4Y9. This small book is a thorough guide with excellent historical and technical information.

Nadeau, Luis. 1986. *Modern Carbon Printing.* New Brunswick, Canada: Atelier Luis Nadeau.

> Monochrome carbon transfer and carbro methods.

Nadeau, Luis. 1987. *Gum Dichromate and Other Direct Carbon Processes, from Artigue to Zimmerman.* New Brunswick, Canada: Atelier Luis Nadeau.

> See earlier comments about Luis Nadeau.

Naef, Weston. 1978. *The Collection of Alfred Stieglitz: Fifty Pioneers of Modern Photography.* New York: Viking Press.

> All prints are reproduced in a dreary monotone of black and white with unfortunate results for the splendid pictures that are included. Still, the information about Stieglitz's fabulous collection is invaluable, and Mr. Naef is a knowledgeable writer.

Newhall, Nancy 1975. *P. H. Emerson: The Fight for Photography as a Fine Art.* New York: Aperture.

> Excellent book about that "irritating man" who created the school of naturalism and made some fine photographs.

Newman, Thelma R. 1977. *Innovative Printmaking. The Making of Two- and Three-Dimensional Prints and Multiples.* New York: Crown.

> Exotic printing methods, some of which are photographic. A book for serious printers.

Reilly, James M. 1986. *Care and Identification of 19th-Century Photographic Prints.* Kodak Publication G-2S CAT 160 7787.

> This expensive pamphlet purports to be the "first and only comprehensive reference book on the . . . identification of 19th century photographic prints," yet it ignores or minimally details a number of print processes that alternative photographic printers want to know about. Kodak should give this otherwise laudable effort a serious reworking before another edition comes out.

Scopick, David. 1991. *The Gum Bichromate Book: Non-Silver Methods for Photographic Printmaking.* 2d ed. Boston: Focal Press.

> A practical, well-written, and comprehensive treatment of gum printing, from simple monochromes to complex color separation printing. It also contains a fine bibliography for the serious student of this pre-modern methodology. It is overly detailed for someone who just wants to give gum printing a try. Such a person should consult Crawford's book.

Stevens, Dick. 1993. *Making Kallitypes.* Boston: Focal Press.

> An extremely thorough treatment of this specialized and beautiful process. Vandyke is one variety of kallitype printing.

Stone, Jim. 1979. *Darkroom Dynamics: A Guide to Creative Darkroom Techniques.* Boston: Focal Press.

> Some very interesting, even some offbeat, darkroom methods. A number of these will translate into gumoil applications.

Wade, Kent E. 1978. *Alternative Photographic Processes: A Resource Manual for the Artist, Photographer, Craftsperson.* Dobbs Ferry, N.Y.: Morgan and Morgan.

A seminal book that pushed the concept of photography as far as any other has. In it, Wade mentions a monochromatic gum and oil printing method and provided Koenig with the initial stimulus to go further with the method. He also writes knowledgeably about such oddball processes as "dusting on" and anthotyping. The book is out of print and quite hard to find. It was published in paperback, and most extant copies are badly deteriorated. The publisher has no plans to reissue this excellent resource.

Weaver, Mike, ed. 1989. *The Art of Photography: 1839-1989.* New Haven, Conn.: Yale University Press.

The catalog of an ambitious historical exhibit shown in Great Britain and the United States. Very fine reproductions of some of the early processes. Lots of information.

Wilcox, Michael. 1987. *Blue and Yellow Don't Make Green: Or How to Mix the Color You Really Want—Every Time.* Rockport, Mass.: Rockport Publishers.

Most photographers are ignorant about color mixing, yet it is an essential aspect of polychromatic gumoil printing. This is a fun book with dozens of color charts and very little text.

Witkin, Lee D., and Barbara London. 1979. *The Photograph Collector's Guide.* Boston: New York Graphic Society Books.

Comprehensive entries on more than 200 photographers, adequate reproductions, a glossary of photographic terms, collection locations, and more.

NOTES

1. There are currently two journals devoted to technical information and new developments in the field of alternative process photography.

 The Alt Photo Review. This informal periodical is edited by Keith Dugdale in England. Information about subscribing is available by calling 01736 330200 or via e-mail at tapr@compuserve.com.

 The World Journal of Post-Factory Photography. The editor is Judy Siegel. Information about subscribing is available by writing Post-Factory Press, 61 Morton St., New York, NY 10014 or via e-mail at editor@post-factory.org.

2. Of general interest is the Alternative Photographic International Symposium (APIS). This meeting takes place in the summer and has been convened, so far, in Paris, Bath, and Santa Fe. People interested in alternative processes come from around the world to listen, exchange information, and show work. A reliable source of information about dates and program can be obtained from Bostick and Sullivan (see suppliers).

3. The Alt Photo List. To subscribe: send an e-mail message to alt-photo-process-request@usask.ca with the following text in the body of the message: "Subscribe alt-photo-process-l." The last symbol is the letter l not the numeral 1. This is a daily exchange of technical information about all alternative photographic techniques.

Annotated Suppliers List

Bostick and Sullivan
1541 Center Drive
Sante Fe, NM 87505
505-474-0890
richsul@earthlink.net

> This is a small, one-man and one-woman operation, which is run in a first-rate fashion. It is the best and cheapest supplier of platinum and palladium chemistry. It also supplies related chemistry, fine papers, books, patient advice to novice printers, and even a few food recipes in its whimsical but finely produced catalog.

Daniel Smith
4310 First Avenue South
Seattle, WA 98134-2302
800-292-6137

Fabriano paper and numerous other high-quality papers, oil paints, and brushes are available at reasonable prices, reliably shipped. The catalog is superb, with gorgeous color and detail. The editor often reprints a wide range of artwork in its pages and makes sure that the articles are rich with information. The catalog is worth careful reading like no other this writer has encountered.

Eastman Kodak Company
Rochester, NY 14650
800-242-2424

The "Big Yellow" is listed somewhat ironically. The company's attitude toward art photographers seems mainly to be one of indifference, especially when one considers the help and materials it *could* supply to printers and photographers pursuing the alternative processes. Call Eastman Kodak in Rochester and then call any other supplier listed here. Compare responses and form your own opinion.

Freestyle
5124 Sunset Boulevard
Los Angeles, CA 90027
800-292-6137

An inexpensive, high-quality, and reliable shipper of all manner of photographic materials, including packets of ortho litho film (one does not need the company's premium variety) at really reasonable prices.

Imagers
1575 Northside Drive
Suite 490
Atlanta, GA 30318
800-232-5411

Imagers does an excellent and economical job of scanning slides and negatives onto CDs using Kodak technology.

Photo Eye
376 Garcia Street
Santa Fe, NM 87501
505-988-5152

> This is the place to buy almost any book related to photography. Big mail-order business and super catalog, too. The owner, Rixon Reed, is personable and helpful when you are searching for an inaccessible title.

Photographers' Formulary
P. O. Box 950
Condon, MT 59826
800-922-5255

> The owners are seriously committed to being helpful to the mail-order or phone-order customer. The company is a cornucopia of chemicals at OK (albeit sometimes high) prices. But what a list of products! Gum arabic in powder and liquid form, potassium bichromate, and all the things you need for pre-modern photographic processes are there in Montana. You can talk to the owners at the toll-free number shown above.

Zone VI
Newfane, VT 05345-0219
800-257-5161

> This quality supplier of exceptional view cameras, lenses, enlargers, chemistry, paper, and so forth is run by irascible Fred Picker. The company stands behind its merchandise, and Fred will talk to you about or advise you on your order or correct any mistakes in your order.

Glossary

A + B developer A two-part developing chemistry for litho film to produce very high contrast effects when used as intended by the manufacturer, but significantly less contrast as dilution is increased.

Alternative process A catch-all phrase to mean anything other than straight silver gelatin or resin paper printing. *See also* nonsilver, hand-coated, and premodern.

Bleach A chlorine-based oxydizing agent. The Clorox brand, unscented in dilution as specified, is recommended although other brands may work as well.

Cold press paper (CP) A moderately rough-surfaced watercolor paper with good tooth to hold the oil pigment and results in a painterly effect.

Combination print A term that can mean two things. First, a print that is made from more than one negative or image. Second, a print that is made by using the same positive or negative with one printing process laid over another (e.g., platinum plus gum bichromate) with the one below showing through.

Contact printing frame A good frame is one that holds the positive/negative material snugly against the sensitized paper while ex-

143

posing the "sandwich" under glass to the sun or some other source of light. Prints also can be made by simply placing a heavy sheet of glass over the sandwich on a smooth surface. Frames sometimes are made with UVT plastic, or Ultraviolet Transmissible plastic. This trims the exposure time required.

Contrast A somewhat inexact term that helps us describe prints or transparencies along a continuum from flat (low contrast) to high-contrast imagery. If the conceivable light quality of any image runs from 0 (black) to 10 (white), a high contrast picture will have both 0 and 10 as well as values in between. If it happens to have only 0s and 10s, it will be a pure black-and-white (no grays) image. A low-contrast picture will have a more constricted range of light values, say 0–3, 5–7, or 8–10. Good film transparencies for gumoil are those with definite 0s and 10s, but plenty of values in between as well.

Etch In the gumoil process, etch is a verb that describes the action of bleach on the hardened, residual gum layers left after exposure and development in a water bath. A well-executed etch will eat away just enough of the thinner gum edges to allow for a second (or third) color to be laid down while leaving enough gum for further etching and coloring or leaving as white space.

Finish Gumoil prints can be left as they are after the last coloring and etching. Varnishing or oiling can bring up colors, however, and this can be accomplished by rubbing in, brushing on, or spraying on. Repeated layers may be needed or desired. In addition, varnish is available in gloss or matte surfaces.

Gum arabic This wonderful material is available in powder and liquid forms. For the purpose of gumoil, both forms are useful because the commercially available liquid tends to be a bit thin but can be thickened up a bit with the powder. Not only does gum work as a medium for suspending the sensitizer (potassium bichromate) for hand-coating on paper, but the liquid gum alone can be used as a masking agent in manipulating the oil print.

Gum bichromate or gum prints Since the nineteenth century, gum arabic has been combined with a sensitizer and a soluble pigment, applied to paper, and exposed through a negative under a powerful light source. This can produce beautiful prints only surpassed by adding further layers of gum pigments in registration. It is also possible to print color separated black-and-white negatives to produce gorgeous true color prints, but precise registration is required.

Gumoil process A new process that looks premodern. Unpigmented, sensitized gum is exposed through a black-and-white film positive. After water developing and drying, the open spaces are filled in with oil-based pigments. The next thinner layers (corresponding to intermediate tones) are etched away with bleach and further pigment is added. No registration is necessary even in polychromatic printing, and therefore, no preshrinking or sizing.

Hand-coating The alternative printing processes encompass chemistries that have neither a long shelf life nor sufficient appeal for the commercial manufacture of fully prepared papers. In other words, if you want to make prints in the alternative processes, you will have to find the right paper and learn to mix the chemicals and apply them yourself. The huge number of variables open to the printer may be viewed as a disadvantage by the obsessive-compulsive techno-weenie, or as an enormous advantage by the artist/experimenter. This writer favors the second view.

Hot press paper (HP) Refer to cold press paper for comparison. HP papers are smoother and have less tooth. They are somewhat trickier to use but they are capable of more photographic, less painterly, results.

Latex frisket Commercially available gray liquid that contains latex. It can be spread, dried, and peeled off for masking purposes. It should be removed as soon as possible as the frisket can adhere too robustly to the paper (or paint) and pull off bits of the surface, ruining the picture.

Masking Any process that allows the printer to selectively color, or protect from coloring, some portion of the image. Latex is mentioned above, but it is also possible to mask with tape and liquid gum arabic. Do not use the red liquid mask (mineral spirit based) as it cannot be removed from water color papers.

Nonsilver Because this confusing misnomer is in general use, it must be mentioned here. Nonsilver refers to the actual printing process rather than those materials used to arrive at the point of printing. The image captured in the camera, unless electronic, depends on silver compounds. If the image is enlarged onto a second positive or negative, this is also dependent on silver compounds in the film. Thus, nonsilver should only refer to the final print making. In this carefully restrictive sense carbon, cyanotype, gum bichromate, gumoil, oil, platinum, and palladium prints are nonsilver methods. Kallitype and

Vandyke actually use silver in their chemistries even though they are often included under the nonsilver rubric. Bromoil and bromoil transfer printing, which require a silver bromide paper matrix, may or may not be considered a nonsilver process.

Oil pigment In general, tubed painter's oils are most suitable for the gumoil process. Nevertheless, oil-based pastel sticks, oil sticks, alkyd paints, acrylics, and other mediums are occasionally usable in the process. The pigment, in whatever form, must have the capacity to sink into the open paper spaces and be repelled by the hard gum and to wipe clear with rags or paper.

Opacity/transparency This refers to the oil pigment. Many of the better oil colors will give some indication of their *opacity* (on the tubes)—the ability to cover up underlying paint. Gumoil depends in great part on starting with an extremely opaque color (e.g., lampblack) and moving to less opaque paints so that the entire palette chosen will show in the final print. Interesting exceptions can be taken to this rule. In Color Plate 5, the last color applied was Naples Yellow, a paint with high opacity. Because the limbs were masked and because the yellow was wiped off the blacks and grays with great vigor, it was possible to use this paint effectively.

Ortho Litho film Available in several varieties and qualities. The technique of taking film, which was originally designed to yield only extreme high contrast and bending the rules to yield moderate contrast with good tonality, is explored in the text. Gumoil needs a fairly contrasty positive film to print well. Litho film can be manipulated to provide it. However, if the positive is too high in contrast, the print will be uninteresting. Similarly, a positive too low in contrast will produce a gumoil print that is dull or unreadable.

Premodern As used in this book, the term alludes to a certain quality of a print but not the strict historical location in time of its printing or its printing methods. Thus, gumoil is a premodern method even though it is newer than, say, Cibachrome—electronic imaging—or gelatine silver paper. Premodern is associated with, and overlaps, the nonsilver processes, the alternative processes, and the hand-coated processes.

Printing-out paper Unlike the vast majority of commercial papers, most of the hand-coated papers yield an image during the course of exposure. The coating changes color and, if the transparency is carefully lifted, the transmitted image can be seen below without subjecting the paper to actual development. This is risky because the

transparency, if moved even slightly to one side, will then produce a double image if laid back down for further exposure. Paper coated with the gumoil mixture is a printing-out paper.

Stencil brush This is the most efficient way of applying and working in oil pigments to the image. A stencil brush is very stiff.

UV Ultraviolet radiation is the light wavelength band that seems to activate most sensitizing chemicals applied in hand-coating. In gum-oil, sunlight on a bright clear day is extremely reliable. The old sun-lamps also work when suspended for several minutes over the contact printing frame. Even better is a device called a platinum printer (it also prints gumoil) from Aristo, but beware of other printers that are designed primarily to print a new breed of commercial palladium papers.